BARBARA MORGAN

Prints, Drawings, Watercolors & Photographs

Curtis L. Carter

William C. Agee

Published by

Patrick & Beatrice Haggerty Museum of Art

Marquette University Milwaukee, Wisconsin

in cooperation with

Morgan & Morgan

Dobbs Ferry

NY

International Standard Book Number 0-87100-261-2
Library of Congress Catalog Card Number 88-62482
Printed in the United States of America by Morgan Press, Incorporated
145 Palisade Street, Dobbs Ferry, New York 10522

Published by
THE PATRICK & BEATRICE HAGGERTY MUSEUM OF ART
Marquette University, Milwaukee, Wisconsin
in cooperation with
MORGAN & MORGAN, INC.
Dobbs Ferry, New York

Design by John Alcorn

Distributed by
MORGAN & MORGAN, INC.
145 Palisade Street
Dobbs Ferry, New York 10522

Acknowledgements

William Agee and I shared a longstanding curiosity about Barbara Morgan's artistic contributions in several media. This interest on our part led us to spend several days in 1986 looking at her prints, drawings and watercolors. Morgan's photographs are well known in the art world, but was there sufficient material of significance to mount an exhibition presenting other dimensions of her artistic productivity over the years? With excellent cooperation from the artist and the Morgan family, it was possible to view many works from the 1920s to the 1970s that had mainly been forgotten. Through a careful selection process, we identified approximately forty non-photographs and fifty photographs for the current exhibition.

With the assistance of the Riebel family, and the National Endowment for the Arts, and anonymous donors, it has been possible for Marquette University's Haggerty Museum of Art to mount the exhibition for touring and produce a catalogue that interprets more fully the scope of Morgan's artistic contributions and document a significant representation of her previously unpublished prints, drawings and watercolors in context with her photographs.

The undertaking of such a project involved the cooperation and effort of many. First, thanks to the artist and her sons for lending the works from their personal collections and then to the other anonymous lenders. Thanks is also due to Lloyd Morgan for organizing and making available the personal papers and documents relating to Barbara Morgan's work and also to Liliane De Cock for preparing the catalogue photographs. Thanks also to Steve Eichenbaum and David Hanneken of Curro/Eichenbaum for their assistance with the exhibition poster. Without their many hours of labor the project would have been much more difficult.

William Agee's catalogue essay renders insight into the relationship between Morgan's work in different media and helps locate her work in relation to main developments of twentieth century art. John Alcorn designed the catalogue. Members of the Haggerty Museum staff have devoted substantial time to the organization of the exhibition and to the catalogue preparation. Mark Spencer assisted with the NEA grant and coordinated transportation. Marcia Eidel developed the promotional materials for the travel tour. Elaine Ruffolo, curatorial intern, assisted with catalogue research and preparation. Fay Graetz, Marilyn Meissner, and Mike Skelton typed the catalogue manuscripts. For all these efforts we are very grateful.

Curtis L. Carter

EXHIBITION SCHEDULE

PATRICK & BEATRICE HAGGERTY
MUSEUM OF ART
Marquette University
Milwaukee, Wisconsin
September 29 – November 27, 1988

DAVISON ART CENTER
Wesleyan University
Middletown, Connecticut
August 30 – October 15, 1989

CENTER FOR CREATIVE PHOTOGRAPHY
Tucson, Arizona
December 10, 1989 – January 7, 1990

ROCHESTER INSTITUTE OF TECHNOLOGY
Rochester, New York
Dates to be Announced

*This Exhibition is Funded in Part by
The Riebel Family in Memory of Audrey R. Riebel,
The National Endowment For The Arts,
and Anonymous Donors.*

Contents

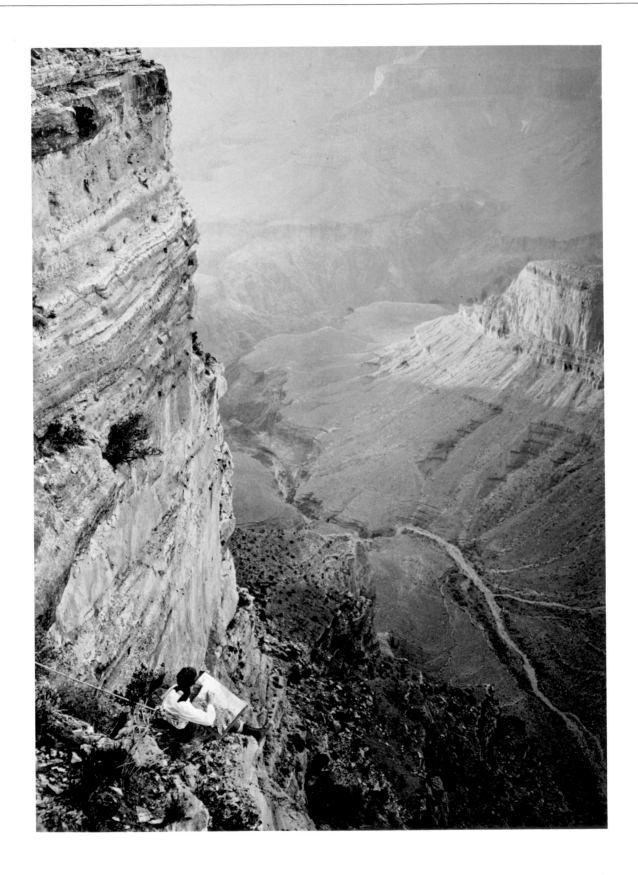

Barbara Morgan Sketching in Grand Canyon, photograph by Willard Morgan, 1928

Barbara Morgan

PHILOSOPHER / POET OF VISUAL MOTION

By Curtis L. Carter

Barbara Brooks Morgan, born in 1900, is an American treasure whose full scope and importance as an artist is yet to be discovered. She is well known in the visual art and dance worlds for her penetrating photographic studies of American Modern dancers such as Martha Graham and Merce Cunningham. Her photomontage and light drawings rank among the classic experiments of modern American photographic art. Morgan's drawings, prints, watercolors, and paintings were exhibited widely in California in the 1920s and in both New York and Philadelphia in the 1930s. She temporarily abandoned these arts and became a photographer in 1935 to allow more time for raising her children. Although she subsequently resumed work in drawing, watercolor, painting, and mixed media, which continued through the 1970s, these other aspects of her work have been largely overlooked since she emerged as a prominent artist photographer in the late 1930s.

An overview of Morgan's place in twentieth century art is long overdue. It is our intent to provide such an overview with special emphasis on the aesthetics and philosophy exemplified in her works. Morgan's extraordinary verbal gifts, through which she has articulated her aesthetics and philosophical views, are an important supplement to her visual expressions. Very often her own words provide the best texts from which to augment the visual testimonies to her expression.

This exhibition offers a representative selection of Morgan's photographs in a context with her drawings, prints, and watercolors from the 1920s through the 1970s. Many of the non-photographic works, and some of the photographs, are shown here for the first time. In order to give a more defined focus to relationships between the photographs and other works on paper, and to provide a meaningful selection suitable for a travelling exhibition of manageable scope, no paintings are included. The exhibition is intended to create greater awareness of the range of Morgan's accomplishments in art, and to provide the viewer a first hand opportunity to explore the

artist's development of rhythmic forces and other themes in various media.

In some respects the exhibition challenges conventional assumptions concerning photography's uniqueness as an artistic medium by inviting viewers to think about similarities between photographs and other visual arts media as well as differences. For instance, John Szarkowski has argued that photography as an independent medium, when compared to painting and other visual media, offers a radically new picture making process that depicts "actual reality" of the world itself, and attempts to bring significance to its fragmented segments by framing them within a finite picture space.[1] Morgan herself initially refused to consider the notion that photographs could be works of art, because they seemed merely to record rather than to create. By comparing Morgan's photographs to her drawings, prints, and watercolors, the viewer of this exhibition is able to rethink the question of whether,

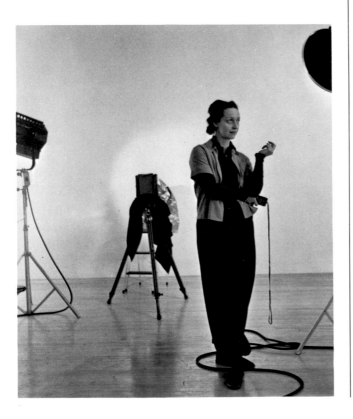

Barbara Morgan in Her Studio, photograph by Willard Morgan, 1942

and in what significant ways, photographs differ from other works of art on paper. Our intent in presenting the photographs with the drawings and other media is an invitation to the viewer to explore and consider their underlying themes rather than to impose any doctrinaire point of view.

Our approach is not to deny the uniqueness of the respective media, but to question the absoluteness of this proposed separation of the arts according to media. A review of more than a thousand works by Barbara Morgan convinced us that important relationships exist among her works, in various media. These include a commitment of the artist to modernist experimentation and design, as well as visual expressiveness based on her idea of the "subordination of realism to the spirit, the idea, and the emotion."

BARBARA MORGAN'S PLACE IN AMERICAN ART

Morgan began her career as an artist and teacher at U.C.L.A. in the mid 1920s. She became an advocate of modern art when most of her colleagues in America were oriented to traditional approaches to art. In a 1926 *Los Angeles Times* article, Morgan wrote: "Modern art when at its liveliest is a movement of discovery of the new beauties and new poignancies of our own age and of all ages, as the quick, not the dead, we owe ourselves the creator's thrill of leaping into this search."[2] A subsequent article by Morgan, published in 1927, further outlines her views on the necessity for growth and change in art:

We get along very well with art as long as it stays in the art histories, for there it is tabulated like the parked cars we pass. But when our own personalities are plastically growing and art, too, is in the modern making then indeed we are in a 5 P.M. traffic jam. . . . It seems strange that although we see the inevitability of changes in the universe we are always reluctant to incorporate it. . . . Now that this peak of leisure yields strange

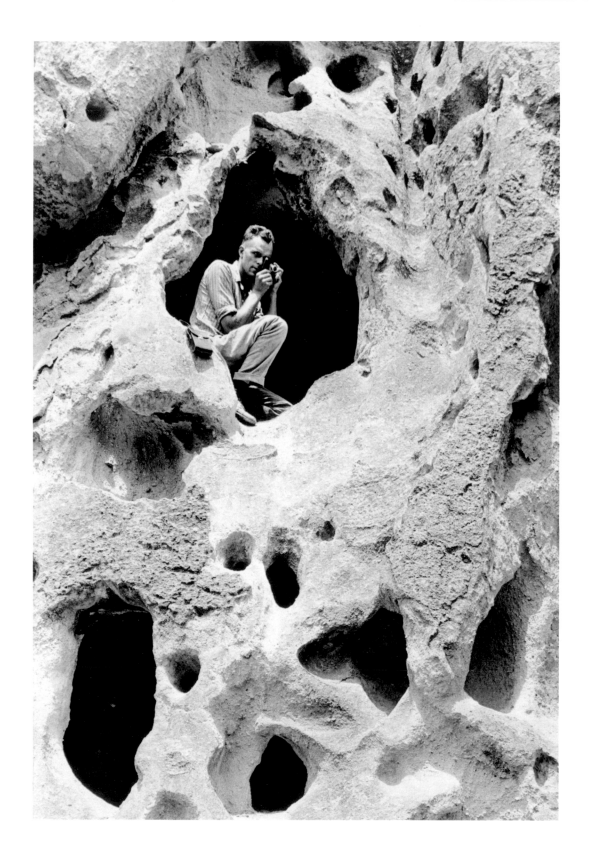

81. *Willard Morgan with Model A Leica in Bandelier National Monument, 1928*

and monstrous creations, there is a great panic and the people fear that their culture is being betrayed by mere capricious novelty seekers and distortionists. But this is only in minds fearful of change. . . . To the elastic mind there is a great urge to grow in the new rhythm of things, to unfold and flower from the soil and seed of our own time.[3]

Morgan's identification with modernist concepts locates her work with respect to the main developments of twentieth century art. Her creative years span a broad scope of changes in style and concept. These changes include the German Expressionist and *Neuesachlichkeit* art of George Grosz and Ludwig Meidner; the photomontage of Man Ray, Moholy-Nagy, and John Heartfield; the Avant-Garde Dadaist art centering on Marcel Duchamp; the Futurist art of Carlo Carra and Umberto Boccioni; Surrealism with Salvador Dali and Joan Miró; and the Social Realist art of Mexican muralists José Clemente Orozco and David Alfaro Siqueiros, as well as the Abstract Expressionists' art and later developments. Morgan shares with the German Expressionists a critique of the societal exploitation of mankind. She enjoys the experimental spirit of the Dadaists, and her uses of rhythmic motion are akin to the Futuristic developments in art.

Although Morgan abhors the egoist tendencies of a Salvador Dali, the whimsey of a Miró's surrealist images is reflected in the spirit of her own drawing and paintings. There is also a strong affinity to the organic rhythms found in the works of Abstract Expressionists such as Arshile Gorky and Willem DeKooning. Morgan draws upon these various sources to forge her own place in modern art. She accepts with the pioneers who generated these various aspects of modern art, the necessity for experimentation and individuality as integral components of any serious approach to art. Her occasional stylistic references to these sources only reinforces her own awareness of a rich and varied world of art which had its beginning in the caves of Lascaux and elsewhere.

From about 1923 through 1929 Morgan exhibited regularly in museum shows at the Los Angeles Museum (1923, 1929), The Fine Arts Gallery of San Diego (1926, 1927), the Oakland Art Gallery (1927, 1929), The Los Angeles Public Library (1929), and other sites in California. She was one of twelve selected to participate in an exhibition of "Paintings by Western Women" held at the Oakland Art Gallery in 1927. In 1929, her sculptural tiles won first prize at the Los Angeles county fair.

Although her watercolors and woodcuts from the 1920s do not appear radical to a late twentieth century eye, Morgan's contemporaries, as reflected in the press reviews of the *Los Angeles Times*, described the work as "experimental." For instance, Prudence Wollet, a Los Angeles critic, wrote the following: "For out and out independence, Barbara Morgan has taken the most liberties yet, in my experience of woodblock art. Every element of her themes, even to the technicalities of framing, contributes ostensibly, in bringing each part into perfect unity of composition and color harmony. . . . I contend that this experimenter bears watching."[4] Morgan continued to exhibit her prints at the Weyhe Gallery in New York and the Mellon Gallery in Philadelphia after moving to New York in 1930.

In 1955, twenty years after she began her career as a photographer, Morgan resumed painting.

What a liberation to swing the brush, feel the squish of paint on the tooth of the canvas . . . and smell turpo in the studio. Best of all . . . the unpredictable was coming out of me. . . . I opened up the dike to what had been dammed up . . . the sensuousness of painting which I had deeply missed . . . the making of a tactile, textured 'thing', instead of an illusion under gelatin! Brush motion began a nerve-stream hookup to my imaginary world.[5]

Morgan's efforts resulted in paintings for several group shows and a one-person exhibition of paintings and drawings in 1961 at the Sherman Gallery in New York.

Her remarks above reveal an understanding of the differences in media, as well as insights into how the artist views the media issue for herself. Was the return to painting a signal that Morgan's true love had all along been painting? Or was it an opportunity for the artist to reconcile for herself certain remaining tensions between photography and painting? Morgan resolved the tension by defining the place of each in her own creative life. Photography is necessary to cope with and adequately present the complexities of our modern environment. Painting, however, enables the artist to present, with greater sensitivity, the interior and personal aspects of human expression:

For me, photography and painting are two irreconcilably different, indispensable opposites . . . that electrify my creative currents . . . to be 'alive in light', I need the attributes of both silver halides, camera and brush[6]

PLACE IN THE WORLD OF ART PHOTOGRAPHY

Morgan's decision to "convert" to art photography in 1935 was the culmination of more than ten years of experience with photographing in conjunction with her husband Willard Morgan. The practical demands of caring for two children were but one factor in this decision. More important for our purposes is that she found photography more suitable as an artistic medium to the challenge of capturing her new city environment of New York, with its machine-like structures and energies.

Her subsequent associations with photographers such as Ansel Adams, Beaumont Newhall, and Minor White, all of whom held her work in high regard, attest to Morgan's high standing in the field of art photography. Morgan shares with Adams a deep respect for symbolism expressed in realistic images abstracted from nature. Morgan realized that realism and abstraction are but contextual points along a continuum of possibilities that can be used for making artistic pictures. She frequently departs from nature's vocabulary to invent her own expressive forms and symbols. To create her own vocabulary, she draws especially upon images of both the city and the dance, manipulating these images at will, as well as the photographic processes, into photomontages or light drawings. Morgan shares with White a poetic, expressionistic vision of photography and a belief that photography, through its artistic modes, is able to convey the essence of the human spirit.

Morgan's photographs fall along two important axes in the history of photography: Expressionist and manipulated image photography. In addition to her previously noted connections with Expressionist photography, her work clearly has strong affinities with artists such as Frederic Somers, and Henry Holmes Smith. Photographic meaning for these artists extends beyond the photograph itself and consists of a symbol expressing personal vision and cultural values. Photography from an Expressionist's point of view is not essentially a vehicle for documentation, but aims for interpretation. Expressionists such as Morgan do not necessarily emphasize visual and pictorial means of description unique to the camera medium, or try to minimize the personal role of the photographer as others of her generation might. An exploration of the relationship of the camera to other visual arts media and subjective transformation of the materials being photographed is essential to their work. Images in photography formed from this perspective are often metaphorical. Similarly, Expressionists such as Morgan argue for a separation of the medium as a fine art from its functional and casual "snapshot" traditions.

The second main axis running through Morgan's

photographs is her experimental uses of manipulated or altered images. Manipulated photographs were very important to Morgan's initial acceptance of photography as an art, because they freed her from any fears that a photograph is a mere record or copy, and demanded of her the highest imaginative and technical efforts. Immediately upon her decision to begin functioning as an artist photographer, Morgan distanced herself from "pure photography" and began creating through photomontage. Photomontage refers to multiple image systems created by such means as combining negatives, double exposures, as well as by cutting and reassembling images to serve a new aesthetic purpose. Morgan's decision to practice altered image photography also extended into experiments with light drawings with a light beam directed by hand motions, and with camera-less photograms.

In pursuing these experimental aspects of photography, Morgan followed a tradition begun by prominent photographers of the mid-nineteenth century such as Robert Demachy in France and H.P. Robinson in England who argued that art photography benefitted from manipulation of the "straight" photographic images. Her more immediate predecessors in photographic manipulations, however, were Moholy-Nagy, Man Ray, and John Heartfield, all of whom were innovators who conducted important experiments through photomontage, Rayograms, and solarized prints. Morgan herself took photomontage beyond its prior usage and virtually invented the techniques for photo-light drawings.

Since she began her art photography in the mid 1930s, Morgan has achieved recognition throughout the world.[7] Peter Bunnell, professor and curator of photography at Princeton University, has written, "Mrs. Morgan is an artist of outstanding ability . . . She has been a significant force in photography for nearly a half century . . . Today she must be considered one of the few living masters of the photographic medium."[8]

AESTHETICS AND PHILOSOPHY OF ART

From what has been stated previously, Morgan falls into the mainstream of modernist-expressionist developments of the twentieth century. Certain concepts necessary to understand her own individual work within these broad categories of modernist-expressionist trends are presented here. These are aesthetic essences, rhythmic vitality, simultaneous multiple perspective, abstraction, and social aesthetics. All of these concepts are expressed both in her own writings and in the various stages of her photographic and non-photographic works.

Aesthetics is the key to understanding Barbara Morgan's art, because she integrates her artistic and philosophical vision inseparably in her art. For the present purposes, "aesthetics" refers to the attitudes, values, and concepts that influence artists and assist in forming the public's responses to their works. With Piet Mondrian, Edward Weston, and other modern artists of the twentieth century, Morgan believes that an artist's role is to search for "aesthetic essences." In a 1927 article she wrote, "The creative person's role, as I see it, is to extract the most significant, most moving aspects—to refine and essentialize them, to get rid of the unnecessary, and to articulate the subtlest, most intense, most profound expression possible."[9] Returning to this theme in 1971, Morgan wrote, "Essence yes, but even more than essence, I learned . . . that by looking at something and absorbing it emotionally, intellectually . . . that you could inwardly transform it . . . you get symbolism . . . external meaning that goes beyond the individual reality."[10] Morgan believes that the artist's role is to organize that perceived essence or energy into something that speaks aesthically and communicates some life experience. This is nowhere better exemplified than in her *"Lamentation,"* 1935 (No. 63) which expresses an intense experience of grief and anguish.

Barbara Morgan with 4x5 Graphlex, photograph by Willard Morgan, 1942

The discoveries that Morgan uncovers in her search for essences lead her to affirm the corollary expressionist notion that the artist's role is to convert the essence of an emotional vision into artistic means, which then arouse aesthetic emotion in the viewers. This process is especially evident in Morgan's photograph of José Limón in *"Mexican Suite"* (peon), 1944 (No. 78), which portrays the agony of a peon being made a serf by a Spanish Conquistador. In this particular work, the peon appears in a predominantly horizontal position:

. . . struggling upwards, head back, knees up, toes crunched, hand gripped, his rib cage so tensely arched that the ribs are visible . . . The skeletal feeling of his torso and the encircling darkness symbolize the partial death he is suffering. It is almost like a crucifixion—the physical and spiritual agony of a tortured race epitomized by the body in pain.[11]

Perhaps the most central idea in Morgan's aesthetics is rhythmic vitality, or what a gestalt psychologist such as Rudolf Arnheim might refer to as the dynamic forces that apply alike to the visual arts and to the structural orders of feeling, perception, and the entities of the material world. Morgan initially discovered the concept of rhythmic vitality in the Chinese Six Canons of painting. She learned from the Chinese that the goal of artistic expression is to present the essence of life force. Morgan views rhythmic vitality as the central concept which permeates all of her artistic efforts whether in prints, drawings, paintings, or photographs.

Whether my work is large or small, abstract or realistic, the one thing that must be present is Rhythmic Vitality. Sometimes I find it logical to keep the realistic or external form of things and other times I find it more meaningful to eliminate certain details while preserving others. In photo-

montage I go clear over into fantasy and in my light drawings into total abstraction. It doesn't matter if it is dance or montage or people or nature. There always has to be the presence of energy.[12]

Rhythmic vitality exists in the flow of human emotions and the dynamic processes of world civilizations, according to Morgan. Similarly, it operates within nature's processes such as geological formations that emerge as the Grand Canyon. These various forms of rhythmic vitality find parallels in the creative processes that produce Morgan's photographs and other art works.

Because of the complexity and multiplicity of the modern world, Morgan recognized a need in her art to express multiplicity in thought and emotion. This need led to simultaneous multiple perspective, which allows the artist to compress into a single image multiple aspects that would otherwise have to be read in a sequence of separate images that could not adequately portray the tensions and interrelationships of various aspects of a situation. Photomontage is the artistic vehicle that best exemplifies Morgan's approach to this concept.

Photomontage originates in this multiple kind of life we are living . . . the chief function of montage is that of mirroring this complex life. The multiple form which expresses it must not be chaotic but instead it must be channeled until it makes sense . . . Photomontage also originates in the peculiar technical character of the photographic processes. One photographic image can easily be projected over another in the enlarger . . . unlike painting, the negative permits the making of any number of prints of any desired size and these may be cut up, cropped, silhouetted, painted upon, and combined with other materials, and used with great flexibility.[13]

Especially important to Morgan's work is the

fact that photomontage embraces simultaneity, multiple perspective, and the ability to create both empathy and tension by juxtaposing formal means and discontinuous thoughts and subjects from different images. For example, *City Shell*, 1938 (No. 46) juxtaposes the natural form of a shell aged over possibly millions of years against the newly formed, man-made Empire State Building. Similarly, photomontage can show overtones of fantasy, reality, memory all at the same time. For Morgan this meant that the photomontage was able to give a truer picture of the actual complexity of things than would a single image photograph.

Although photomontage emphasizes multiplicity, the artist must somehow harmonize the multiple aspects into a coherent design for the sake of visual clarity and comprehension. Morgan's genius in this respect make her photomontages a model of aesthetic and visual clarity.

While Morgan's works embrace both abstract and representational images, her art reveals a strong interest in abstraction, which concerns the formal aspects of art emphasizing light, color, line, shape, and texture and their interrelationships. Her early woodcuts such as *Mono Lake*, 1931 (No. 6) and the later drawings such as *Myths of the Future*, 1955 (No. 26), strongly reflect her concern with these matters. Her applications of abstraction extend into the photographic medium as well. This is especially evident in the light drawings such as *Emanation I*, 1940 (No. 58). Photographic abstraction is for Morgan ". . . . the form-changing, form-making, expression inherent in the medium by which photography recasts the objectivism . . . to project subjective vision."[14] Early on Morgan realized that variations in lighting created many diverse possibilities for creating abstract designs in photographs as well as for interpreting the subjects. The lighting for each dance image is constructed in great detail in order to bring forth the necessary abstract qualities of the photograph.

The torso composition of Martha Graham in

"Ekstasis," 1935 (No. 62) illustrates especially well how Morgan uses lighting to heighten the abstract forms of a dance image:

. . . the side and back lighting frees and solidifies the sculptural form; the tonal shift of the triangle of light projects distance and supports a rhythmical monumentality. [15]

Especially important to Morgan's aesthetics, is her affirmation of the social role of art. With the philosopher Plato, Morgan affirms that the artist must not only be a good photographer or painter, but must also be a good person. Her belief that the artist has a deep social responsibility to the community and the world is expressed directly in her 1930s images of the city and in subsequent statements on nuclear issues. By contrast, Morgan's non-photographic art reflects her interest in abstract art and, even when figurative, it is notably lacking in images depicting social concerns. This observation reinforces our prior claim that her decision to become a photographer was influenced substantially by her need for a medium that would better respond to the urban social issues found in her New York environment.

Deeper art influences stemmed from earliest memories of the radiant southern California landscape, with smog undreamed of. Neither rich nor poor, I was not aware of massive human tragedy until later I moved with the crowds in the subway . . . on the pavement of the streets of New York. [16]

Her sensitivity to the tragedies of a nation in depression during the 1930s is reflected in the early photomontages of New York life.

Meanwhile the depression. Day after day men out of work shuffled listlessly through Madison Square. In the west I had witnessed dire poverty, especially among many Mexican families, but despite physical want they still enjoyed sitting in their doorways soaking up the sun, singing impassioned songs to guitars. There was not the claustrophobic, spiritual poverty of the city breadlines in a machine world. This was before the Dust Bowl Oakies—before industrialism and smogged out relaxed humanism. [17]

In a 1938 interview, Morgan commented:

There was a challenge for me in New York . . . I felt the conflict between the heroic proportions of the structures as against the people, who were hurried, subordinated, not masters of themselves . . . I wanted to paint it all, but when I tried I could not express what I felt. Painting I decided was not the proper medium . . .

I want to express the conflict between the people and their environment. . . . to subordinate technology to human values, to dignify and glorify man. There's no justification for our mechanized world unless it contributes to a good way of living. I want to show that in my photographs. [18]

Among the most powerful of these social statements is the photomontage, *Hearst Over the People*, 1939 (No. 44), which is a satiric caricature of William Randolph Hearst with his face distorted and octopus-like tentacles dominating over a crowd of protesters at Union Square in New York. The piece is intended as a commentary on the oppressive power of the Hearst papers to manipulate opinions and affect the welfare of the people in ways not in their interest.[19] In *City Street*, 1937 (No. 43), Morgan contrasts ironically the Empire State Building, a majestic symbol of wealth and power, with the suffering people below, "desperate souls . . . marching across the street in utter despair, searching, not knowing what was their future."[20] This photograph depicts Morgan's despair that so little caring and compassion for people could exist along side such achievements of grandeur. A contrast of wealth

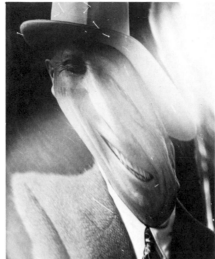

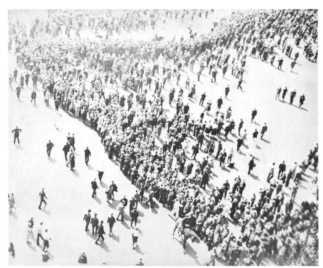

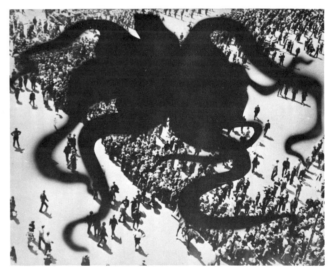

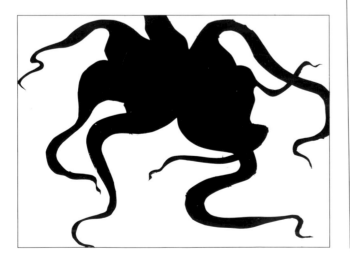

Components used by Barbara Morgan in the photomontage *"Hearst Over the People,"* 1939 (No. 44).

"Concerned as I was with Yellow Journalism as a distortion of the 30s, I decided to visually distort the consumate Distorter: editor William Randolph Hearst. So, I undulated the enlarger paper for portrait distortion, made an imaginary octopus cut-out and interrelated the two images over a May Day crowd photograph I had shot from a seventh story window in New York."

—Barbara Morgan, "My Creative Experience with Photomontage," *Image* (14:5-6, 1971): 19.

and poverty appears also in her *Macy's Window, 1939* (No. 83) which portrays a lone woman dressed simply in black staring longingly at a clothed mannequin in the window of Macy's Store. Psychological despair is the theme of *Use Litter Basket,* 1943 (No. 48) which portrays the pressures of a fragmenting urban environment.

Through such works as these, as well as her personal involvement with the causes of American Indians and other tribal people, opposition to the misuse of nuclear power, advocacy of world peace and cooperation, and warnings against pollution of the mind through the mass media, Morgan has lived her belief that artists have responsibilities to mankind beyond the need to make aesthetically moving works of art.

CONTRIBUTION TO DANCE PHOTOGRAPHY

Barbara Morgan's contribution through her photographs to the history of American dance has yet to be fully documented or appreciated. In addition to her artistry in making the exquisite photographs of Martha Graham, Doris Humphrey, Merce Cunningham, and others, she may well be responsible for introducing thousands of Americans to their first images of modern dance. Beginning around 1938 and extending into the early 1940s, her dance photographs travelled to over 150 colleges and other exhibition spaces in New York, Chicago, Philadelphia, the West Coast, New England, and many places between. A 1939 article from *New Masses* commented as follows on the tour:

For communities which have not had the opportunity to see in reality the revolution which has overtaken the dance in our era, these photographs are a revelation. For students of the dance and for future ages, they are an indispensable document.[21]

A tour of fifty of her American Dance photographs was organized in 1945 by the Inter-American office of the National Gallery in Washington, D.C. for the United States Department of State.[22] The exhibition, which was shown in Rio de Janero, Havana, and other sites, brought modern dance to South America through Morgan's images of Martha Graham and other modern dancers. The accompanying catalogue, published in Spanish and Portugese, included an interpretive essay by John Martin, dance critic for the *New York Times*. The exhibition opened in New York at the Museum of Modern Art and was shown in San Francisco at W. & J. Sloanes prior to its journey to South America.

Morgan's importance as a photographer of American modern dance is affirmed in a 1939 letter from New York Public Librarian Dorothy Lawton.

Being essentially a visual art and not sharing the statelier quality of painting and sculpture, its only hope for permanence lies with the modern camera. When this instrument is directed by an artist sensitive to the spark of the dancer's inspiration, the immortalization of the group of solo dancers who are making history in America today is assured . . . At first a painter, she (Morgan) became impressed by the beauty of kinetic art and studied dancing in order to transfer to canvas this illusive quality of motion . . . I foresee in her the founder of an American archive of the dance . . .[23]

Morgan had recognized early in her career her own potential and responsibility for contributing to the history of dance. While attending a commemorative event for Isadora Duncan, Morgan realized a special need for documentation of dance when she noted the paucity of the few remaining momentos assembled as a testimony to Isadora Duncan whose dancing had launched a new era of American dance.

I realized then that photographers have an opportunity to be of service . . . through documentation that is needed perhaps more for the dance than for other art forms.[24]

Although Morgan's statements reveal an awareness of the documentary value of her dance photographs, she is quick to point out that merely recording performances of dance or of dancers is of no interest to her. Instead, she transforms her insights into the dances into photographic works of art in their own stead. This point is eloquently made in her statement for the press release of her 1945 South American tour.

As a photographer, I have had the joyful responsibility of capturing and communicating these phenomena of the human spirit which would not endure beyond performance. The pictures were composed in action while the dancers performed especially for my modern speed camera and lights. I continually sought to discover the fluid relationships of light-time-motion-space-spirit by which I could release—not the mere record—but the essence of dance into the photographic image.[25]

In an article titled, "Dance Photography," written in 1942, Morgan defines the central problem of dance photography as "to express the spirit of dance movement in terms natural to the camera." In order to present dance photographically it is necessary to see dance photographically and be "keyed to rhythmical coordinations in the control of camera and lighting and stage space . . . This means controlling the choice and interpretation of pictorial instant, of shutter timing, of camera perspective, of expressive lighting, of stage spacing, and suitable film and processing."[26] Through these means the photographer is able to transcend the mechanical means of mere recording and function as an interpretive artist. The artistic aim foremost in Morgan's thoughts is to make photographs that select and clarify significant instants and to arrest and preserve these moments for enjoyment and study as only the still camera can do.

Morgan's account of her own process reveals clarity of purpose and means essential to excellence in art. In preparation for photographing dance, she watched the dancers in performance and rehearsal until the music and the flow of the dance structure were firmly in mind, and major instants which symbolized the dance were clearly in her memory.

At this point photographic imagination commences. I begin to think of these dance gestures through the camera finder, framing in active space, framing off dead space, playing the camera straight on, from below, to one side, close up, thinking always of the light . . . I work as a kinetic light sculptor . . . I think of the bodies in their space as a series of convex and concave forms in rhythmic movement. I send light upon these forms, making patterns of light tones, and dark tones; over convex heads, backs, breasts, thighs, bent knees . . . the full emotion of the design in the sum of these parts . . . I demand from myself a combination of an expressive emotional projection and a good abstract design . . .

I want the full dramatic presentation of emotion that gave rise to the dance conception.[27]

Morgan's compassion for people in an era of social crisis extends to the dancers and their role in society.

I felt that in the anguish of the period, there wasn't enough joy or confidence or hope, and I began to see it in the dancers who were barely scraping along. They had no money, they were doing something they believed in. They were giving out joy, confidence, hope. Here was something human, something warm, something dedicated. They were giving out to people and I began to photograph them.[28]

61. Martha Graham, *"Satyric Festival"* (with studio lights), 1940

Morgan's photographs of the dance never appear to be didactic, because their artistic form and technique clearly establish them as profound works of aesthetic interest and merit. Nevertheless her dance images carry the "joy, confidence, and hope" that she finds in the modern dances of Martha Graham, Merce Cunningham, Erick Hawkins, José Limón, Doris Humphrey, Charles Weidman and others whose dances she photographed. Throughout her works there is evidence that she joins dancers in their affirmation of creative life forces.

CONNECTING LINKS AMONG MEDIA

The point of the current exhibition has been to suggest connections and relationships between the drawings, prints, and watercolors and the photographs. A shift of her base from California to New York resulted in distinct changes reflecting a contrast of physical and social environments, as well as a different focus of media. The principal links between the works in her drawings, prints, watercolors, and photographs are developed in greater detail in William Agee's companion essay in this volume, "Barbara Morgan: Painter Turned Photographer." From my perspective, the connecting themes that Agee finds in his comparison of particular works across media lines exemplify the aesthetic themes such as aesthetic essence, rhythmic vitality, and abstraction that have been discussed in greater detail in my essay. On the other hand, multiple perspective and social aesthetics, which are ideas central to her photographs, do not appear to carry over into the non-photographic works. This observation is consistent with Morgan's statements that she found in photography a medium more attuned to the cultural multiplicities and societal complexities of the modern world and better able to portray the human tragedies and hopes of people living within that environment.

Given this realization, it is puzzling that Morgan again chose to return with apparently much satisfaction to the very media that she previously had found unable to express matters so vital to her. Perhaps the answer lies in her own philosophy of multiple perspectives in art and life. In the end she must have realized that no single art medium can adequately portray all of the subtle features of life in the depth that an artist of great breadth and sensitivity requires. If, as she says, "the camera becomes net and channel to trap the latent image . . ." the pen and brush must be the probe and scalpel through which images are formed in a delicate balance between artistic consciousness and technical mastery.

Barbara Morgan in Her Darkroom, photograph by Jacob Deschin, 1971

Notes

1. John Szarkowski, *The Photographer's Eye* (New York: Museum of Modern Art, 1966), 4-9.

2. Barbara Morgan, "Modern Art," *Los Angeles Sun Times* (June 13, 1926, Part III): 31.

3. Barbara Morgan, "The Meaning of Modernism in Art," *Artland* (Los Angeles, February, 1927): 4.

4. Prudence Wollett, *Los Angeles Times* (December 7, 1929).

5. "Barbara Morgan," *Aperture* (Rochester, 1964,11:1): 35.

6. "Barbara Morgan," *Aperture* (Rochester, 1964,11:1): 36.

7. For the fascinating details of Morgan's career as a photographer see for example the following: Etna Kelley, "Barbara Morgan: Painter Turned Photographer," *Photography* (September, 1938 vol. 6. no. 73); Jacob Deschin, "Barbara Morgan: Permanence Through Perserverance," *Photography Annual* (1971): 6-24, 108-113, 170,171,182: Barbara Confino, "Barbara Morgan: Photographing Energy and Motion," *Saturday Review* (October, 1971 LV, no. 41): 62-66; Casey Allen, "Camera 35 Interview: The Influencial Photographs of Barbara Morgan," *Camera 35* (May, 1977): 56-60; *Photographer* (September, 1938 vol. 6. no. 73): 6-7.; Ruth Spencer, "Barbara Morgan," *British Journal of Photography* (13 June, 1975): 512-515.

8. Peter Bunnell, Letter to the Author, September 12, 1977.

9. Barbara Morgan quoted in *Confino*, "Barbara Morgan . . .": 66.

10. Barbara Morgan, *Quadraille* (Bennington College, May, 1971): 12.

11. Barbara Morgan quoted in *Confino*, "Barbara Morgan . . .,": 66.

12. Barbara Morgan quoted in *Confino*, "Barbara Morgan . . .,": 62-66.

13. Barbara Morgan, "Photomontage," in *Miniature Camera*, edited by Willard Morgan and Henry M. Lester (New York: Morgan and Lester publishers, 1938), 145. See 147-167 for an extended explanation of photomontage processes.

14. Barbara Morgan, "On Abstraction in Photography," *The Encyclopedia of Photography* (I, 1964),58.

15. "Barbara Morgan," *Aperture* (Rochester, 1964, 11:1):16.

16. "Barbara Morgan," *Aperture* (Rochester, 1964,11:1):36.

17. "Barbara Morgan," *Aperture* (Rochester, 1964,11:1): 9.

18. Etna M. Kelley, "Barbara Morgan: Painter Turned Photographer," *Photography* (September, 1938, 6:73): 6.

19. Barbara Morgan quoted in Dorene L. Ross, *Photomontage Photography: as Explained and Discussed in the Work of Barbara Morgan*. Masters Thesis College of New Rochelle. (May 27, 1979),64.

20. Morgan quoted in Ross, *Photomontage Photography*. "Morgan's account, "City Shell" records her humanitarian concerns while also detailing the exact formal compositional means to express this concern.": 62, 63.

21. Elizabeth Noble, *New Masses* (January 31, 1939): 29. Many letters of request and appreciation for this exhibition are in the correspondence of Barbara Morgan, including negotiations for fees and prints at prices that seem astoundingly low by today's standards.

22. Information concerning the planning of this South American exhibition is contained in correspondence between Porter McCray Chief, Inter-American Office, The National Gallery, Washington, D.C., Margaret D. Garrett, Acting Chief, and Barbara Morgan. The correspondence dates from March, 1944 through September, 1945.

23. Letter from Dorthy Lawton to Barbara Morgan, August 2, 1939.

24. Barbara Morgan, quoted in Etna Kelly, "Barbara Morgan: Painter Turned Photographer," *Photography* (September, 1938, 6:73): 7.

25. Press release for the Latin American Tour of Barbara Morgan Dance Photographs, prepared by Margaret D. Garrett, Acting Chief Inter-American Office, National Gallery of Art, August, 1945.

26. Barbara Morgan, "Dance Photography," *The Complete Photographer* (March 10, 1942,3:18): 1132-1133.

27. Barbara Morgan, "Dance Photography," *The Complete Photographer* (March 10, 1942 3:18): 1135.

28. Barbara Morgan, quoted in Leonard N. Amico and Stephen R. Edidens, *"The Photographs of Barbara Morgan,"* Williams College Museum Art Gallery (March 1-31, 1978): 9.

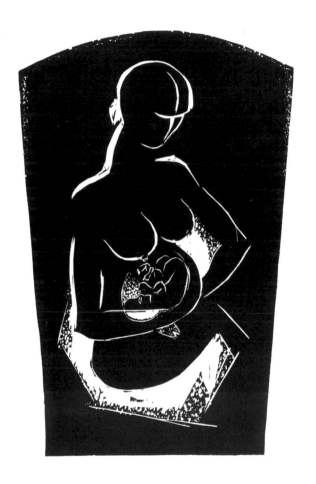

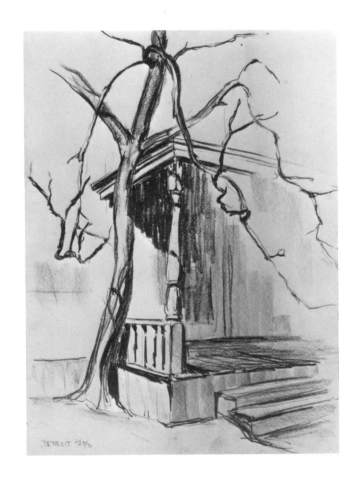

8. *Growing,* 1932 12. *Detroit,* 1931

Barbara Morgan

AMERICAN PAINTER TURNED PHOTOGRAPHER

By William C. Agee

Certain photographs of Barbara Morgan now stand as classic images in the canon of twentieth-century photography. The light drawings (the first works of art I ever saw), the studies of Martha Graham, or the famous photomontages *Spring on Madison Square*, 1938 (No.45), and *City Street*, 1937 (No.43), for example, come immediately to mind. Yet these deservedly famous images, still as compelling as ever, indelibly etched in the history of photography, were not born overnight. Nor do they belong uniquely to the history of photography. They have as their sources ideas and aspirations in a large body of watercolors, drawings, and prints that first date from the early 1920s, long before Barbara Morgan turned her attention to photography. Her work as a graphic artist, still little known, should rightfully be seen as a formative, crucial step in her artistic development. In fact, her shift to photography was gradual, beginning in 1925 when she met Willard Morgan. In 1935, after the birth of her two sons, she turned full time to the new medium.

By 1928, she had achieved considerable acclaim as a painter in southern California, and in the late thirties she was known as a "painter turned photographer." During the 1920s she was highly respected as an articulate and visionary spokesperson for modern art at a time when the new art was still a novelty in California. So deeply ingrained was the graphic impulse in the twenties that almost thirty years later, clearly missing watercolor and ink, she returned to these media in a series of large drawings that dramatically expanded the scope of her achievement. Morgan's work on paper is valuable in its own right, and it makes her photography all the richer and more rewarding.

Barbara Morgan herself has never made a secret of these beginnings. As she emphasized the continuity of all forms of art and life, so she has stressed the wholeness and continuity of her own art and life. She has often spoken of how deeply affected she was as a young girl, when her father, a thoughtful and philosophical man, spoke of the

millions of atoms dancing inside otherwise motionless objects, and of how birds and animals, no less than people, were filled with ideas to do things. Since then, she has said, she has always "searched for the invisible urges," the animating impulses at the heart of life. Barbara Morgan is possessed of a poetic soul which permeated her visual art from its very inception. Thus, it was always clear to her that photomontage, for example, was but a continuation in another medium of the verbal-visual metaphors that filled her life from an early age. For her, photography evolved naturally and gracefully from her early painting. All art, she came to understand, no matter what the style or medium, was united in revealing variations on the universals of the human psyche, as well as on life's fundamental themes.

Barbara Morgan's art, be it a watercolor of the early '20s, or a photograph of 50 years later, reveals clear, recurring and common internal themes. Further, her photography demonstrates an ongoing dialogue as much with the painting, and even sculpture, of the twentieth century as with the history of photography. This continuity may not be immediately apparent. We are struck by the skill and sensitivity of her watercolors of the early '20s, for example, *Early California Eucalyptus Tree*, 1921 (No.36), done while she was a student and then young faculty member at UCLA. Although they cause us to speculate on what course her career might have taken had she not turned to photography, they first appear primarily as an accomplished type of late Impressionism we associate with advanced art in southern California at the time. Yet it is significant that from the start Barbara Morgan chose the natural world, the abundance and grandeur of sky and tree, rather than a man-made setting. For it is to the state of natural things, the natural order, that her art gravitated. Even when her photomontages depict an urban setting, as in *City Shell*, 1938 (No. 46) she often does so to contrast it with

the grace and beauty of a flower, a leaf, or a shell.

Thereafter, we soon grasp that the real subject of the watercolor is the growth, and the abstract patterns of undulating movement in the lush eucalyptus foliage, a metaphor for the vital forces of life. These same forces are evident in the high fauve color and strong drawing in the watercolors of nudes, for example, *Seated Female Nude*, 1929 (No. 38) and plant life such as *Flower*, 1929 (No.41). Even more dramatic is the extension, in two watercolors of the late '20s, of rhythmic pulsations, from a naturalistic mountain scene, *Mountain Landscape*, 1929 (No. 40) into a band of strong color in a distilled abstraction, *Wave*, 1929 (No. 39). Wave lengths of essential forces recur throughout her photography, be it in the dance series, the light drawings, or the Beech Tree series of 1945. We find such forces as well at the heart of her later drawings, albeit now in highly abstracted and accelerated formats.

Although worlds apart from the California settings, the same crackling energy is manifest in the apparently barren tree nestled next to a frame house in the drawing *Detroit*, 1931 (No. 12). Here, an insistent linear movement carries the branches over the surface as if propelled by electrical charges from some hidden cosmic generator. Although in a black and white medium appropriate to its urban setting, the work recalls passages in Cézanne's landscapes of the 1880s; Morgan inbues the scene with her unique sense of nature that became ever more expansive, leading to the seemingly endless proliferation of branches in the photograph *Delicate Beech*, 1945 (No. 91). Nearly the entire surface is covered by the patterning of the branches, recalling the overall texturing in the paintings of Mark Tobey and even hinting at the famous all-over drip paintings begun by Jackson Pollock in 1946-1947. In the photograph *Corn Tassel Through Broken Window*, 1967 (No. 93) she reintroduced a variation of this motif—single, independent lines—to produce an entirely different mood and effect.

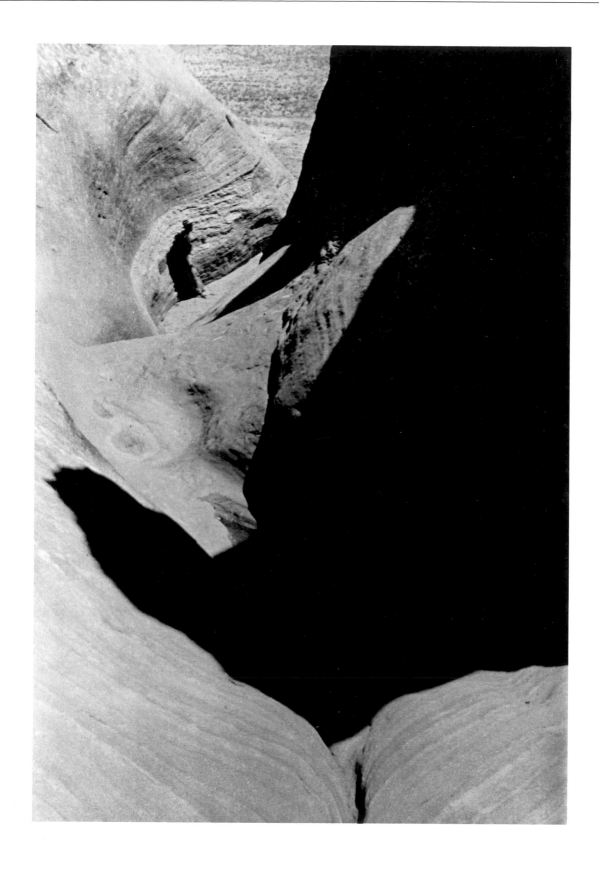

80. *Willard Morgan Descending Canyon de Chelly, 1928*

Rhythmic motion, but now that motion emanating from human beings, animates her woodcut *Rain Dancers*, 1931 (No. 7). Because she understood the beauty and force, as well as the significance of the ritual dances performed by the Southwest Indians, she later immediately understood the importance of Martha Graham. In each type of dance, Barbara Morgan saw what she called "spiritual-emotional energy," and her famous studies of Martha Graham would be unthinkable without the early studies of motion carried out in the woodcuts. Indeed, her earliest figure studies of the human anatomy, dating from 1923, now seem as nothing less than Graham preludes, for they too are filled with motion that seems spiritual as well as physical.

The patterning first evident in the eucalyptus tree watercolor was progressively enlarged and made more abstract, resulting in a fuller and more enveloping web of natural emanations, as we see in two other woodcuts, *Mono Lake*, 1931 (No. 6) and *Eroded Lava*, 1929 (No. 2) and in the sweeping forms of some of the later drawings. These shapes, which seem to move across the surfaces like glacial forces, remind us of the paintings of Georgia O'Keeffe, Arthur Dove, and John Marin, the American modernists who similarly gravitated to the inherent movement of natural forms. In this sense, Barbara Morgan was of her times, of the reverence for nature, of the belief in the vital forces of life, expressed by abstract patterns. In this, she had learned from the famous teachings of Arthur Wesley Dow, who had also influenced Dove and O'Keeffe. These works are first-rate prints in their own right, and should be enjoyed as such. However, it is also evident that the same sense of organic life informed her earliest photographs, as in the rich formations in *Willard Morgan Descending Canyon de Chelly*, 1928 (No. 80) and the ceaseless rippling of *Wind Ripples in Mono Lake*, 1929 (No. 82). Later, the same type of primeval shaping lies

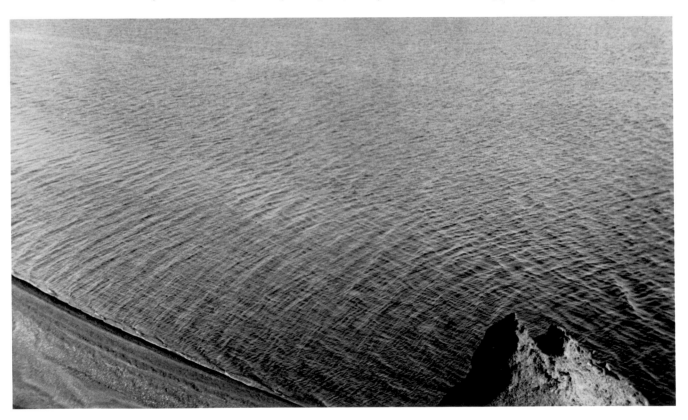

82. *Wind Ripples in Mono Lake*, 1929

at the heart of *Fossil in Formation*, 1965 (No. 50) and *Nuclear Fossilization*, 1979 (No. 53).

By 1930, Barbara Morgan could give equal voice to the most elemental impulses of the world in both abstract or figurative formats. In the black and white woodcut *Abstraction*, 1930 (No. 4) the hard edge, geometric forms imbue us with the sense of being present at some dramatic event of cosmic significance occurring before our very eyes. Or, in the more painterly, looser washes of the watercolor *Mono Lake*, 1931 (No. 42) we feel transported from the here and now of a specific site, back in time, to a liquid, pre-historic realm, in flux, to the very birth of the world, a metaphor of the inner landscape of the psyche. It is this same spirit that is the generating principle in many of the famous dance photographs, as in *Fossil in Formation*, 1965 (No. 50). A more literal depiction of imminent birth is in the drawing of a pregnant woman (probably a self-portrait), *Nude*, 1935 (No. 16) which was also done in the photographic medium in *Pregnant*, 1940 (No. 84). The intense humanity and reality of this drawing recalls the entire modernist tradition of the female nude from Courbet, Manet and Gauguin to the early Picasso of 1906. Two prints, *In the Bath*, 1931 (No. 9) and *Growing*, 1932 (No. 8) are other poignant images of birth and fertility, of new beginnings. The one recalls the perspectives of Bonnard and the color and drawing of Rouault, the other the grace and simplification of Archipenko, whose retrospective at the Los Angeles County Museum in 1927 had deeply impressed her. Later, the themes of birth and the evolution of new worlds was a recurring motif in the drawings of the '50s and '60s.

After moving to New York in 1930, Barbara Morgan was fascinated by the city and came to feel that the precision of its steel contours could best be captured by photography. The Empire State Building, completed in 1932 and the symbol of the new modern city, appeared frequently in her photography. Yet she had first captured it in a drawing, *New York Empire State Building*, ca. 1934 (No. 15), that emphasized the sheer verticality of the skyscraper amid dense man-made canyons, so different from the vast spaces of southern California and the southwest that were a deep part of her. Coming from the west, she had decidedly mixed feelings about the city; what better way to capture these conflicting feelings and the simultaneous streams of movement in the city than the method of photomontage? Her images in this technique are among the most memorable and compelling in all her photography. In their unrelenting, insistent way, *Protest*, 1940 (No. 47) or *Hearst Over the People*, 1939 (No. 44) for example—are unsurpassed as statements of the conflict of natural man in a complex, often alien, technological world. But—as we should suspect by now—the source for these famous pictures lies in another medium, in a pastel drawing *Untitled*, 1932 (No. 13), a city scene fusing four separate views of windows, roof tops and watertowers, all depicted in a differing scale and perspective. Put in a broader context, this type of pictorial fusion can be said to have evolved from the simultaneous imaging of disparate views found in aspects of Cubism from around 1914-1918, which she would have become aware of as a student at UCLA.

In fact, Barbara Morgan's art—her drawings and her photographs—is enormously rich in its references to the entire culture of modern painting, drawing and sculpture. To suggest some of these roots and parallels is to understand the full extent of the continuity of her art and life. For example, her photography of Martha Graham and company should rightly be seen as the immediate heir of Degas, and of the depictions of Isadora Duncan made famous by the watercolors and drawings of Rodin and Abraham Walkowitz, a lineage that the artist herself has often noted. The affinity with Rodin, one of the fathers of modern art, goes even deeper, however. In her photographs of the dancers Merce Cunningham or Erick Hawkins in "*El Penitente*," 1940 (No. 72)

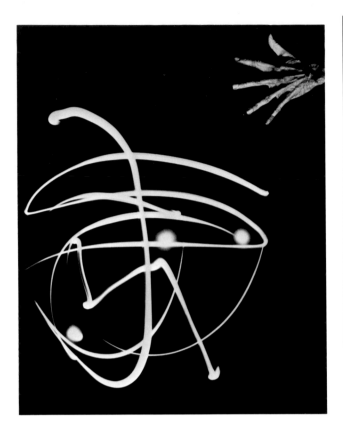

59. *Pure Energy and Neurotic Man,*1941

and "*American Document*" (trio), 1938 (No.66) we see the same tension and dynamic piercing of space that gives Rodin's sculptures *Walking Man* and *Bronze Age* their stamp of modernity. The vitality and life we feel in all her dance photographs surely recall Matisse in his monumental paintings *The Joy of Life*, 1905, and the two versions of the 1911 *Dance*. We may also think of Matisse's *Joy of Life* (which she knew well from her study at the Barnes Foundation) when looking at her *Girl Playing Recorder*, 1945 (No. 89), a deceptively simple photograph that in fact is a contemporary update of Titian and the entire western pastoral tradition. The sculpture of Brancusi comes to mind in the purity of the ovoid shape in Barbara Morgan's *Amaryllis*, 1943 (No. 85); the drawing *Divers-Harlem Pool*, 1934 (No. 10) will recall the realism of Thomas Eakins

and the sequential photography of Marey, and Muybridge. It may fairly be said that to a large extent the deep core of felt emotion in Morgan's photography stems from the fecund reference it bears to all art. Literally, this is true, for she frequently has recalled her visit to the cave paintings at Lascaux as one of the decisive events in her life.

It is also true that to gain something important, the artist (like the rest of us) must give up something important; and sooner or later the artist is compelled to recapture that something, for it is too much a part of her to let it go forever. Photography uniquely enabled Barbara Morgan to capture the simultaneity of the dance and the modern urban experience. But clearly she missed the immediacy and directness that only the hand moving across paper can give and this led her back to ink and watercolor drawing in the early '50s. Thereafter drawing once more became as much a part of her as photography, and she reclaimed her heritage as a painter that she had established more than thirty years earlier, a continent away. The image, the touch, the feel, of these drawings are remarkable. The surface can be open and expansive, with a minimum of line and shape, as in the drawing *Untitled*, 1960 (No. 27), or *Myths of the Future*, 1955 (No. 26); or, it can be dark, closed, ominous, as in *Perceivers*, 1963 (No. 21). They can be a stark black and white; or offset with one or two highlights of color; or filled with washes of light yellows, oranges, and blues. The force of linear movement can be controlled and centered, as in *Acorn Round*, 1961 (No. 20) or threaten to disintegrate the boundaries of the surface as in the powerful drawing *Untitled*, 1960 (No. 17) or *The Walk*, 1964 (No. 32). Throughout, we are witness to the artist tracking the very impulses of life itself, impulses made all the deeper by her now long experience. The primeval, unending forces that shape us and the world around us, are rendered with much the same wonder as we can

imagine her as a child listening to her father describing the invisible dance of atoms.

The later drawings may be said to combine the intuitive, instinctive affinity for the world of natural forces that stamped much of the best American art of the 1920s, with the highly charged, linear writing of the automatist surrealists, Miró, Masson and Matta, and the American Abstract Expressionists, especially Arshile Gorky and Jackson Pollock. The difficulty, if not impossibility, of separating media in Barbara Morgan's art, is borne out once again when we consider the significance of her drawing with light in 1940 in the formation of these ink and watercolor works, for the same darting energy is evident in both. The light drawings look back to the photography of Moholy-Nagy and Man Ray, but also forecast the all-over drawing found in much American painting after 1945. Can we not say, then, that she had never given up drawing at all, but had only transferred it to another medium?

Barbara Morgan, now 88 years old, participated in the implantation of modernism in this country when modernism was not widely accepted, when it was still a cause to be championed. She added significantly to the new American art in its early years of the 1920s and '30s, and to its better known post-1945 phase. Her art is defined by its continuity. The understanding of the continuity of modernism and the establishment of modernism as a particular style and attitude has been under attack recently by a younger generation of "post-modernist" critics. It is no longer fashionable in these circles to discuss the peaks of accomplishment achieved by the heroes of modernism or their struggles in its cause. But Barbara Morgan is a hero, and it is from the roots planted by heroes that we all come.

Checklist

PRINTS, DRAWINGS, WATERCOLORS AND PHOTOGRAPHS

PRINTS

1. *The Hunt*, 1926
 Woodcut, 9¾ × 16 in.
2. *Eroded Lava*, 1929
 Woodcut, 9⅜ × 12 in.
3. *Untitled*, ca. 1920-1930
 Colored woodcut, 11½ × 14 in.
4. *Abstraction*, 1930
 Woodcut, 9⅞ × 8⅝ in.
5. *Untitled*, 1931
 Woodcut, 12⅛ × 12 in.
6. *Mono Lake*, 1931
 Colored woodcut, 10½ × 13 in.
7. *Rain Dancers*, 1931
 Colored woodcut 4/25, 12¼ × 14 in.
8. *Growing*, 1932
 Woodcut 5/20, 13 × 8½ in.
9. *In The Bath*, 1931
 Colored monoprint, 10¾ × 8 in.
10. *Divers-Harlem Pool*, 1934
 Lithograph 18/40, 11½ × 13½ in.
11. *The Kernel of Corn*, ca. 1955
 Monoprint, 17¼ × 15½ in.

DRAWINGS

12. *Detroit*, 1931
 Charcoal and ink, 13¼ × 9⅞ in.
13. *Untitled*, 1932
 Pastel, 9¾ × 12 in.
14. *New York Hudson River*, 1934
 Charcoal, 16⅞ × 21¾ in.
15. *New York Empire State Building*, ca. 1934
 Conte crayon, 17 × 12½ in.
16. *Nude*, 1935
 Chalk, 24¼ × 17 in.
17. *Untitled*, 1960
 Ink, 11¾ × 14⅜ in.
18. *Vibrations Through Air and Earth*, 1960
 Ink, 13⅞ × 16½ in.
19. *Orbital Episode*, 1960
 Ink, 23 × 16¾ in.
20. *Acorn Round*, 1961
 Ink, 18 × 22 in.
21. *Perceivers*, 1963
 Ink, 10¾ × 10¼ in.

INK AND WATERCOLORS

22. *Sun Canyon*, 1961
 Ink and watercolor, 22 × 29 in.
23. *Cosmic Monkey Business*, 1953
 Ink and watercolor, 13⅞ × 21⅜ in.
24. *Fossil*, 1953
 Ink and watercolor, 17½ × 14⅞ in.
25. *Untitled*, 1954
 Ink and watercolor, 14⅝ × 18 in.
26. *Myths of the Future*, 1955
 Ink and watercolor, 14 × 21¼ in.
27. *Untitled*, 1960
 Ink and watercolor, 13⅞ × 11 in.
28. *Updraft*, 1960
 Ink and watercolor, 16¼ × 10 in.
29. *Their Dilemma*, 1960
 Ink and watercolor, 14⅛ × 9 in.
30. *The Phoenix*, 1963
 Ink and watercolor, 11¾ × 11 in.
31. *Untitled*, 1964
 Ink and watercolor, 22½ × 15½ in.
32. *The Walk*, 1964
 Ink and watercolor, 16½ × 20 in.
33. *Passing the Torch* (Louis Horst Memorial), 1964
 Ink and watercolor, 16¼ × 17⅞ in.
34. *Untitled*, 1967
 Ink and watercolor, 12 × 9 in.
35. *Untitled*, 1969
 Ink and watercolor, 12⅝ × 14 in.

WATERCOLORS

36. *Early California Eucalyptus Tree*, 1921
 Watercolor, 13¾ × 10 in.
37. *Visit From Another Planet*, 1929
 Watercolor, 20 × 26¾ in.
38. *Seated Female Nude*, 1929
 Watercolor, 30½ × 22⅛ in.
39. *Wave*, 1929
 Watercolor, 19⅝ × 26⅜ in.
40. *Mountain Landscape*, 1929
 Watercolor, 19 × 26¼ in.
41. *Flower*, 1929
 Watercolor, 26¼ × 19⅝ in.
42. *Mono Lake, California*, 1931
 Watercolor, 9½ × 12½ in.

PHOTOMONTAGES

43. *City Street*, 1937
 Photomontage, 18¼ × 13⅝ in.
44. *Hearst Over the People*, 1939
 Photomontage, 14⅝ × 18¼ in.
45. *Spring on Madison Square*, 1938.
 Photomontage, 12¾ × 15⅝ in.
46. *City Shell*, 1938
 Photomontage, 15½ × 12⅜ in.
47. *Protest*, 1940
 Photomontage, 14¼ × 11 in.
48. *Use Litter Basket*, 1943
 Photomontage, 13⅛ × 15⅝ in.
49. *Hullabaloo*, 1959
 Photomontage-photogram, 18½ × 13¾ in.
50. *Fossil in Formation*, 1965
 Photomontage, 11⅛ × 14⅜ in.
51. *UFO Visits New York*, 1965
 Photomontage-light drawing,
 14⅜ × 13 15/16 in.
52. *Crystallized Skyscraper*, 1973
 Photomontage, 14 × 10⅝ in.
53. *Nuclear Fossilization*, 1979
 Photomontage, 13 × 9⅞ in.
54. *Searching*, 1979
 Photomontage-photogram,
 13 × 9 15/16 in.
55. *Emergence*, 1979
 Photomontage, 13⅞ × 10⅜ in.

LIGHT DRAWINGS

56. *Samahdi*, 1940
 Light drawing, 13⅜ × 10⅛ in.
57. *Cadenza*, 1940
 Light drawing, 13⅜ × 10⅛ in.
58. *Emanation I*, 1940
 Light drawing, 13¼ × 10¼ in.
59. *Pure Energy and Neurotic Man*, 1941
 Light drawing, 18½ × 15⅛ in.
60. *Cosmic Effort*, 1965
 Light drawing-photogram, 17½ × 14⅜ in.

DANCE

61. Martha Graham, *"Satyric Festival,"* 1940
 Silver print, 17 × 13⅝ in.
62. Martha Graham, *"Ekstasis,"* 1935
 Silver print, 19¼ × 15⅛ in.
63. Martha Graham, *"Lamentation,"* 1935
 Silver print, 12⅛ × 10¼ in.
64. Charles Weidman, *"Lynchtown"*
 (Bea Seckler Solo), 1938
 Silver print, 13⅜ × 10 3/16 in.
65. Doris Humphrey, *"Passacaglia,"* 1938
 Silver print, 13⅛ × 10½ in.
66. Martha Graham, *"American Document"*
 (trio), 1938
 Silver print, 13⅛ × 17½ in.
67. Doris Humphrey, *"Square Dance for
 Moderns"* (waltz), 1938
 Silver print, 16⅞ × 11⅝ in.
68. Louise Kloepper, *"Statement of
 Dissent,"* 1938
 Silver print, 16¾ × 14⅛ in.

69. Martha Graham, *"Every Soul is a
 Circus,"* 1940
 Silver print, 14 × 16¼ in.
70. Martha Graham, *"El Penitente,"*
 Merce Cunningham, 1940
 Silver print, 16⅞ × 14½ in.
71. Martha Graham, *"Letter to the World,"* 1940
 Silver print, 17 × 22¼ in.
72. Martha Graham, *"El Penitente,"*
 Erick Hawkins, 1940
 Silver print, 21¾ × 16⅝
73. Martha Graham, *"War Theme"*
 (An Illustration for a Poem by
 William Carlos Williams), 1941
 Silver print, 13⅛ × 17½ in.
74. Doris Humphrey-Charles Weidman,
 "Rehearsal Nightmare," 1944
 Silver print, 14¼ × 18⅝ in.
75. Valerie Bettis, *"Desperate Heart,"* 1944
 Silver print; planned double image,
 single negative, 19 × 14¾ in.
76. Merce Cunningham, *"Root of the
 Unfocus,"* 1944
 Silver print; planned double image, single
 negative, 10⅛ × 13¼ in.
77. José Limón, *"Chaconne,"* 1944
 Silver print, 17¼ × 13½ in.
78. José Limón, *"Mexican Suite"* (peon), 1944
 Silver print, 9⅞ × 13⅜ in.
79. José Limón, *"Mexican Suite"* (Indian), 1944
 Silver print, 17½ × 14½ in.

NATURE AND PEOPLE

80. *Willard Morgan Descending
 Canyon de Chelly*, 1928
 Silver print
81. *Willard Morgan with Model A Leica in
 Bandelier National Monument*, 1928
 Silver print
82. *Wind Ripples in Mono Lake*, 1929
 Silver print
83. *Macy's Window*, 1939
 Silver print, 10⅞ × 15⅜ in.
84. *Pregnant*, 1940
 Silver print, 12⅛ × 9¼ in.
85. *Amaryllis*, 1943
 Silver print, 14⅜ × 10¼ in.
86. *Corn Leaf Rhythm*, 1947
 Silver print, 9⅝ × 13¼ in.
87. *Beech Tree I*, 1945
 Silver print, 16¾ × 12 in.
88. *Beech Tree IV*, 1945
 Silver print, 11⅜ × 11½ in.
89. *Girl Playing Recorder*, 1945
 Silver print, 13⅜ × 10¼ in.
90. *Children Dancing by the Lake*, 1940
 Silver print, 13⅝ × 17 15/16 in.
91. *Delicate Beech*, 1945
 Silver print, 14½ × 14½ in.
92. *Resurrection in the Junkyard*, 1947
 Silver print, 10¼ × 13⅜
93. *Corn Tassel Through Broken Window*, 1967
 Photomontage-photogram, 10 × 12¼ in.

*Photographs in the exhibit were printed between 1984 and 1988.

Prints

Watercolors

Drawings

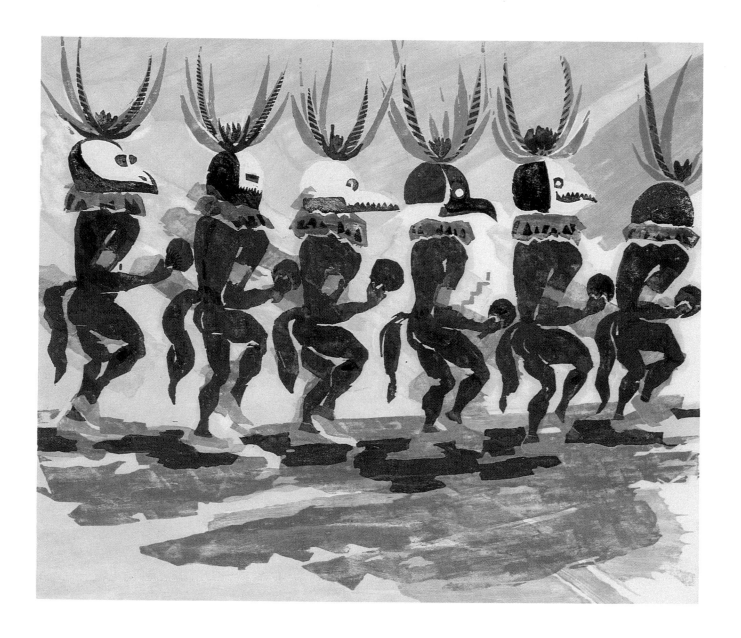

7. *Rain Dancers*, 1931

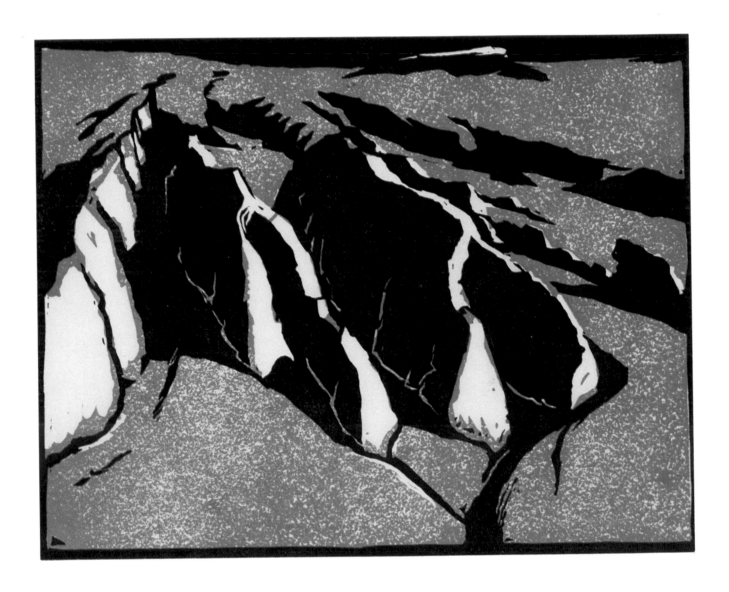

2. *Eroded Lava*, 1929

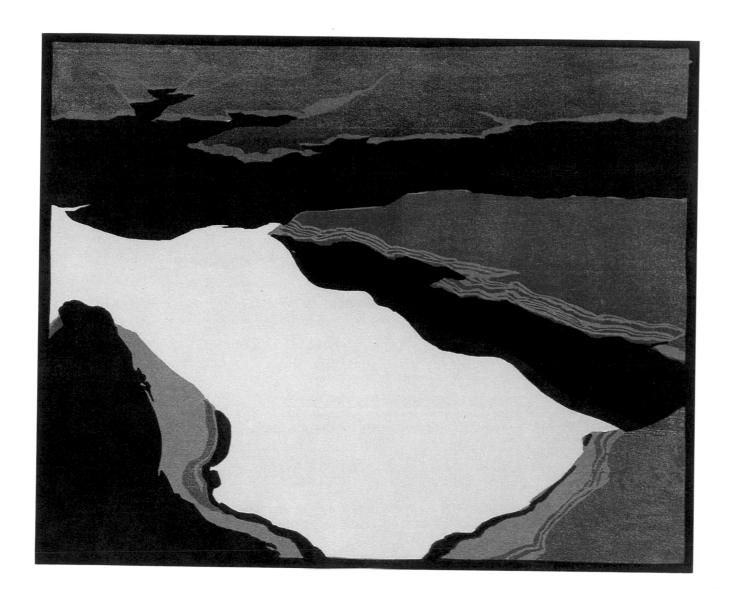

6. *Mono Lake*, 1931

In the Bath, *1931 (No. 9), is a poignant image
of birth and fertility, of a new beginning. It recalls
the perspectives of Bonnard and the drawing and
color of Rouault. Later, scenes of birth and the
evolution of new worlds was a recurring motif in
the drawings of the '50s and '60s.*

WILLIAM AGEE

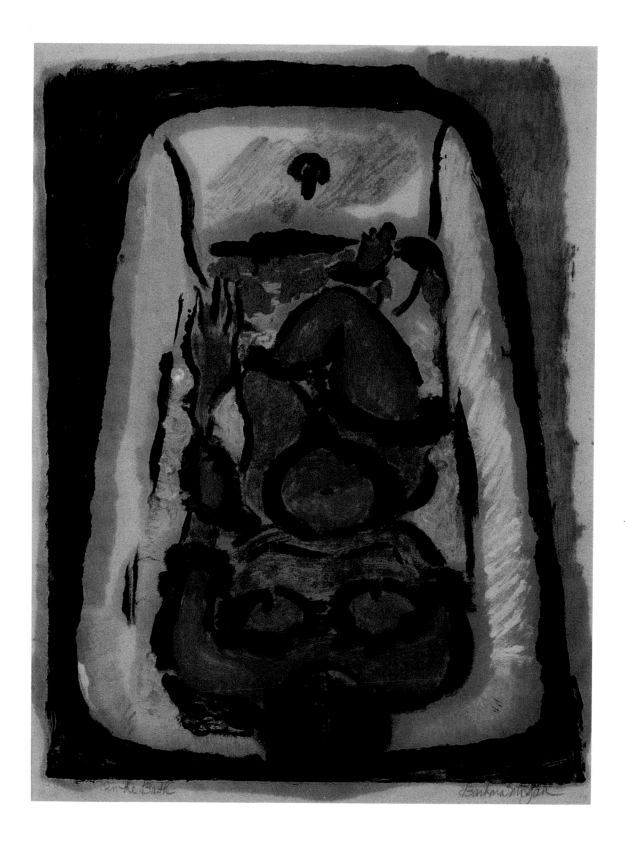

9. *In the Bath*, 1931

1. *The Hunt*, 1926

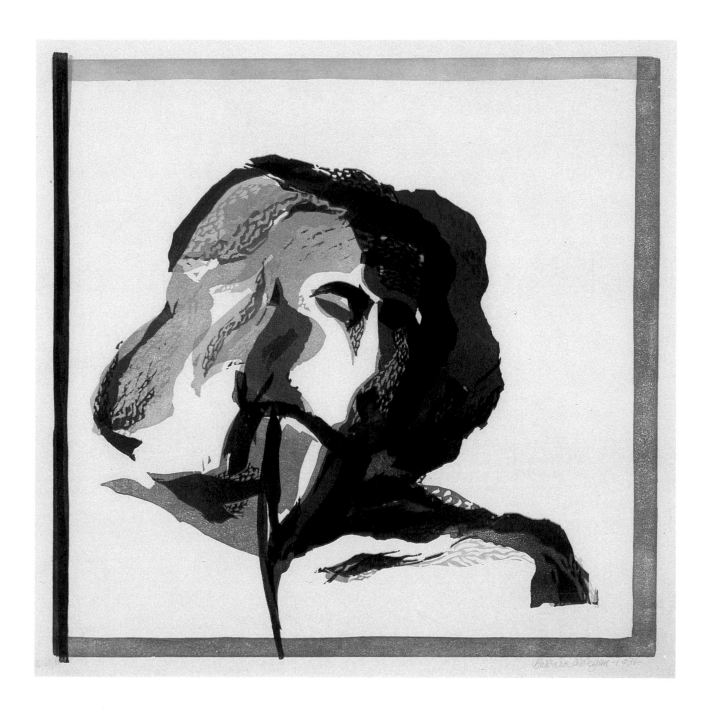

5. *Untitled*, 1931

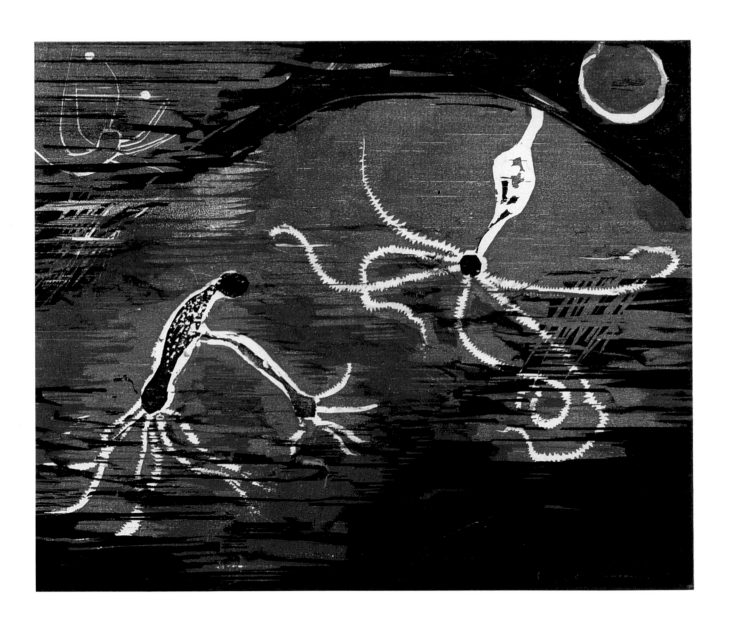

3. *Untitled*, ca. 1920-1930

11. *The Kernel of Corn, ca.* 1955

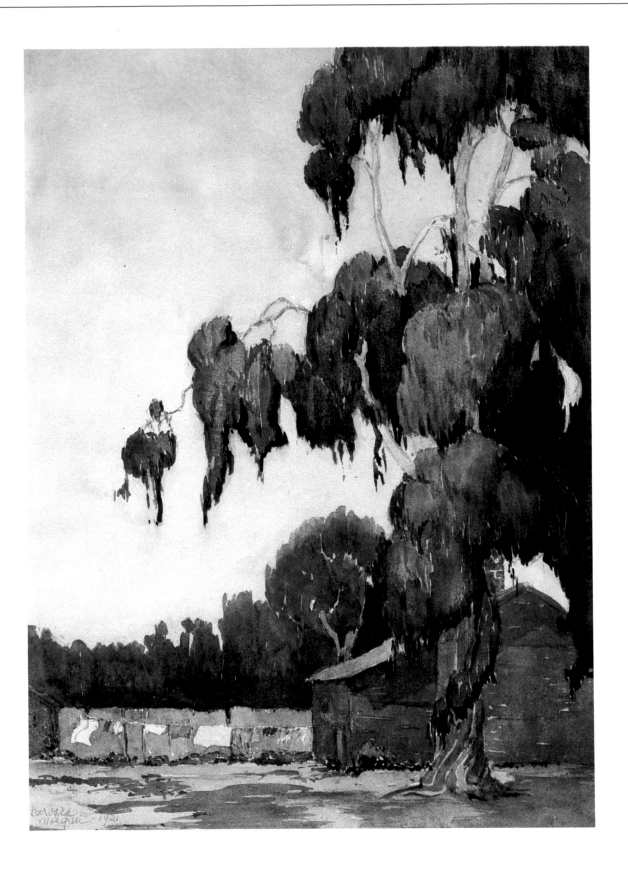

36. *Early California Eucalyptus Tree, 1921*

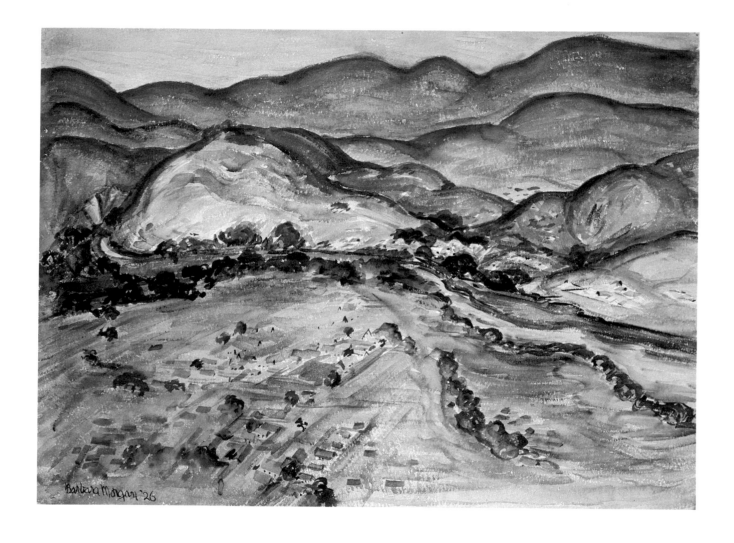

40. *Mountain Landscape*, 1929

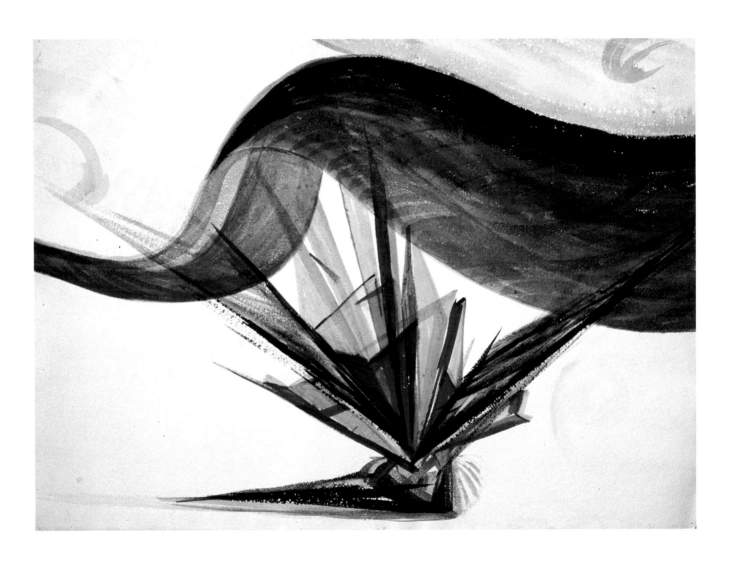

39. *Wave*, 1929

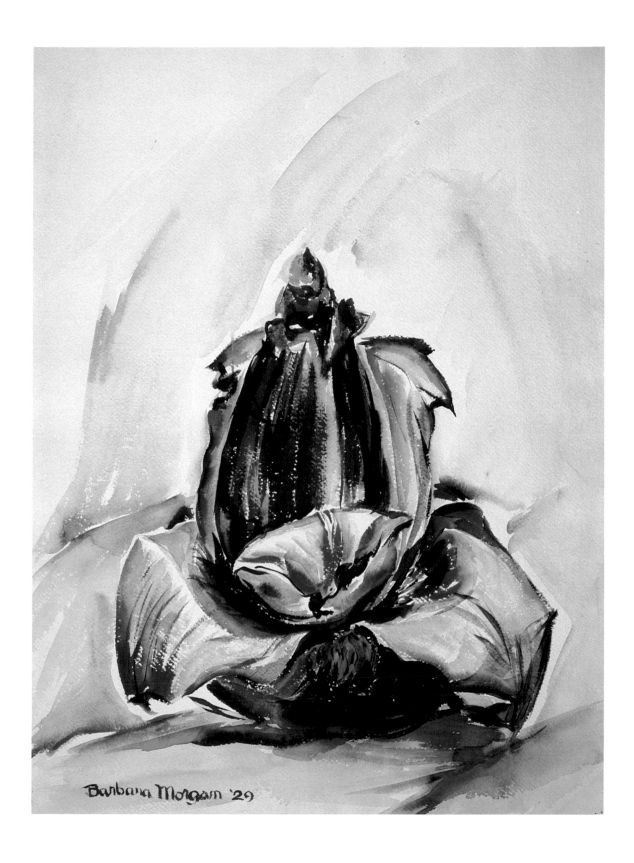

41. *Flower,* 1929

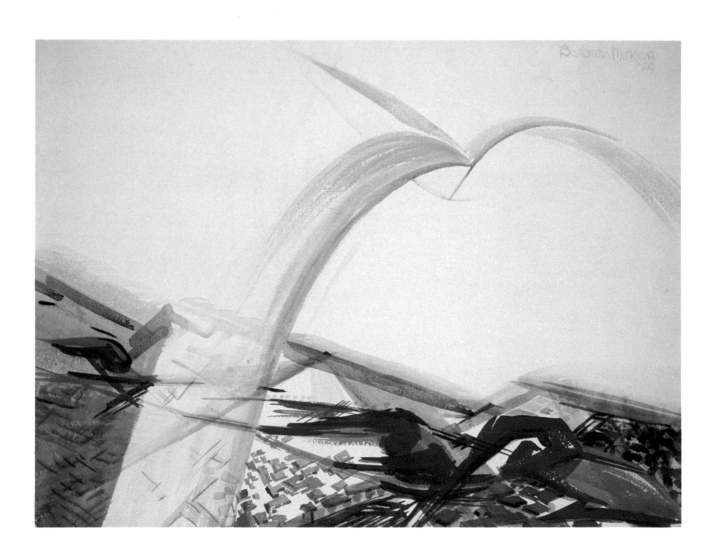

37. *Visit from Another Planet*, 1929

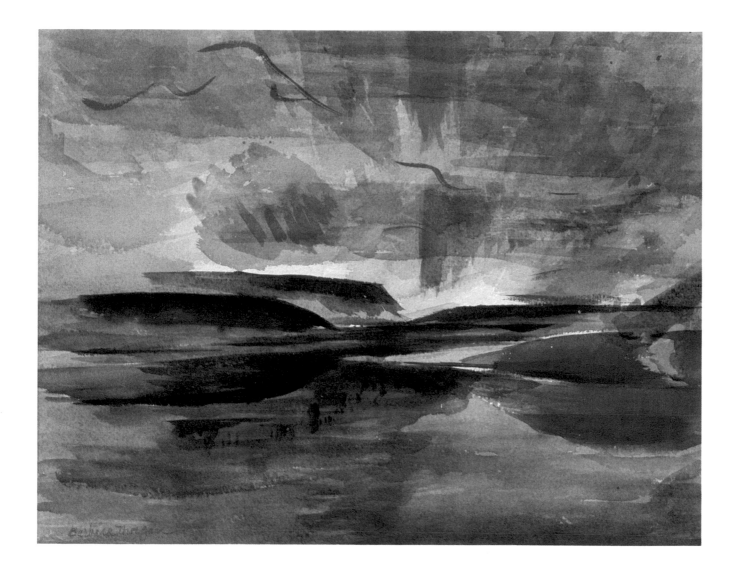

42. *Mono Lake, California*, 1931

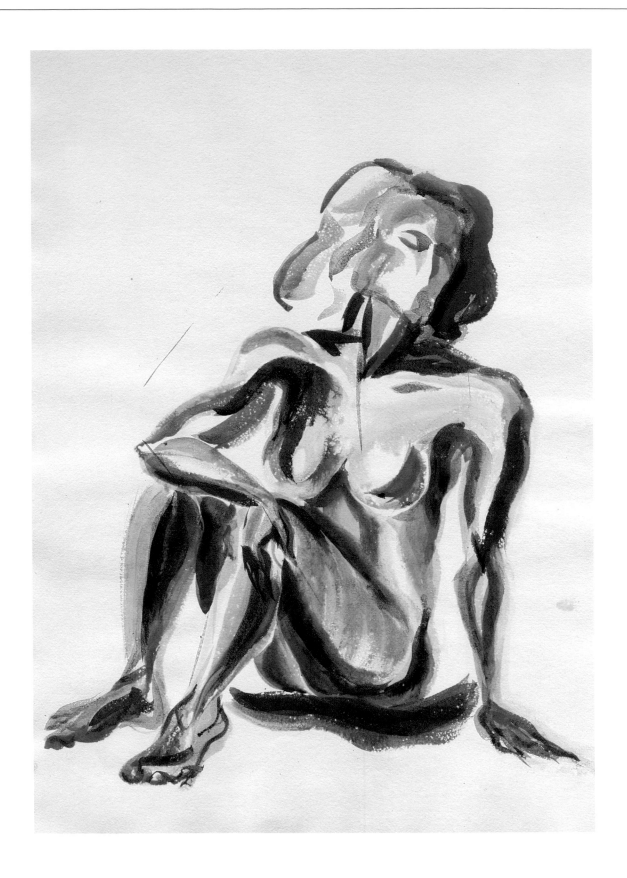

38. *Seated Female Nude*, 1929

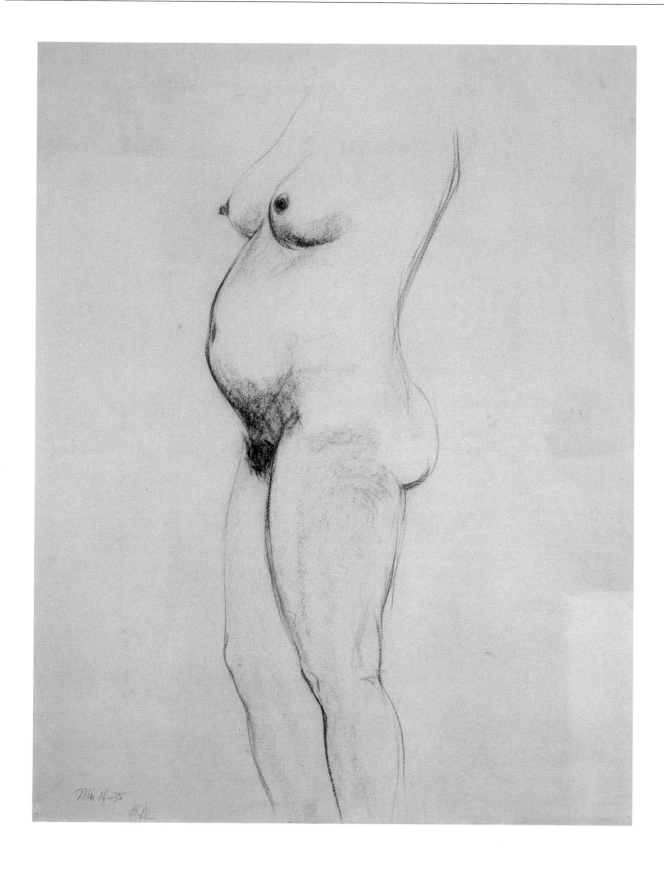

16. *Nude*, 1935

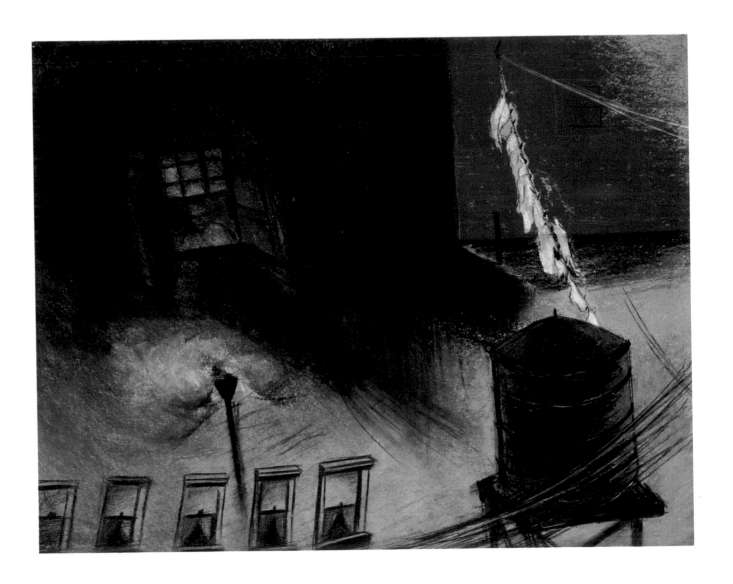

13. *Untitled,* 1932

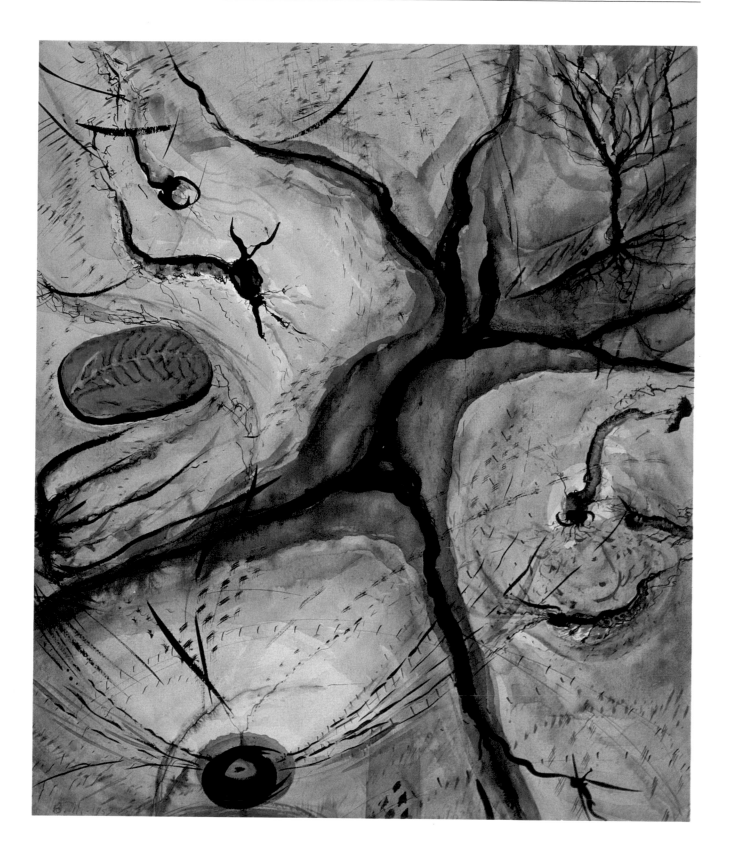

24. *Fossil*, 1953

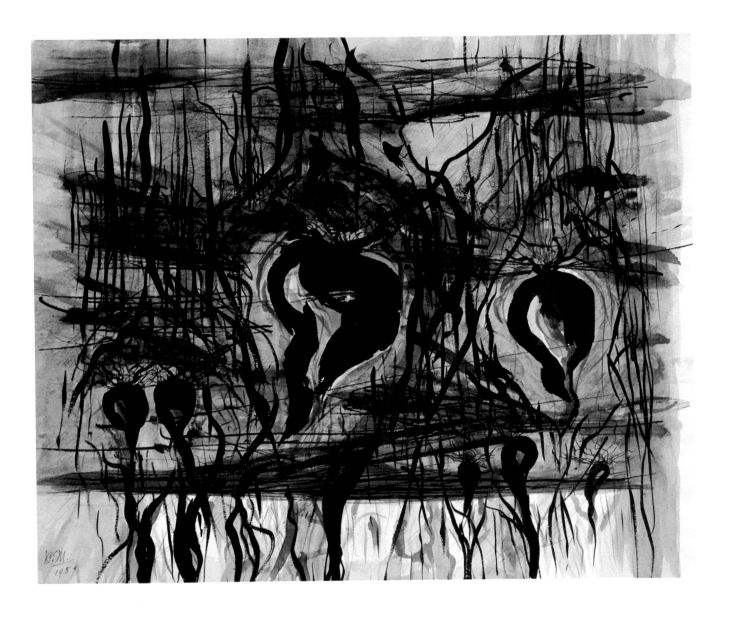

25. *Untitled*, 1954

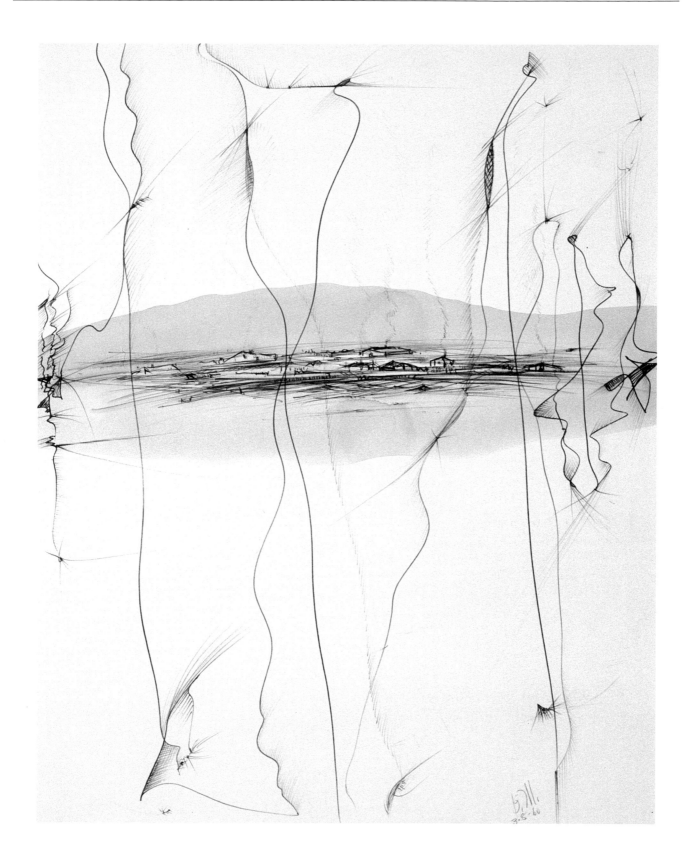

27. *Untitled*, 1960

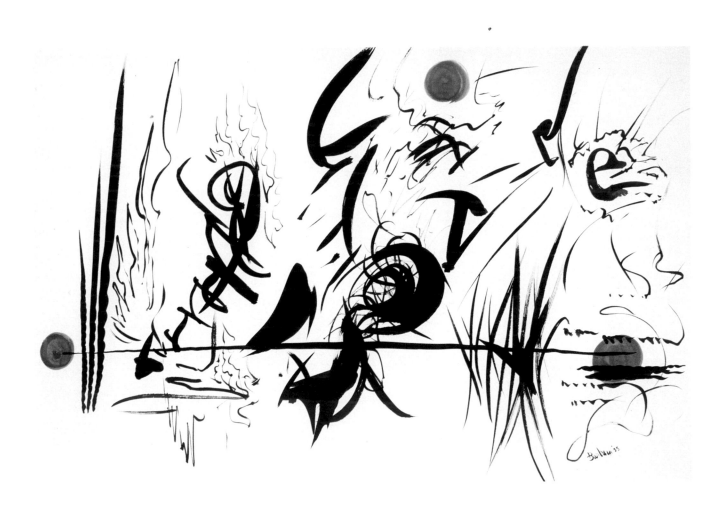

26. *Myths of the Future,* 1955

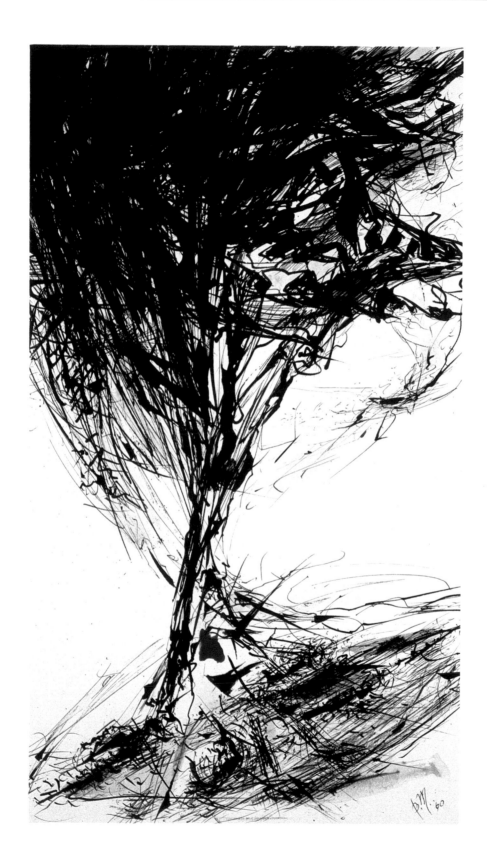

28. *Updraft*, 1960

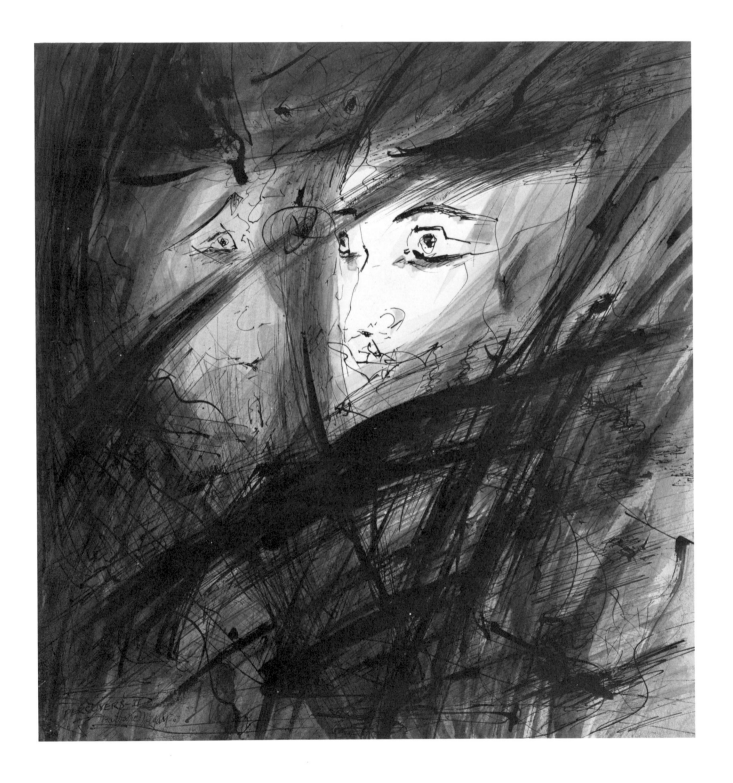

21. *Perceivers*, 1963

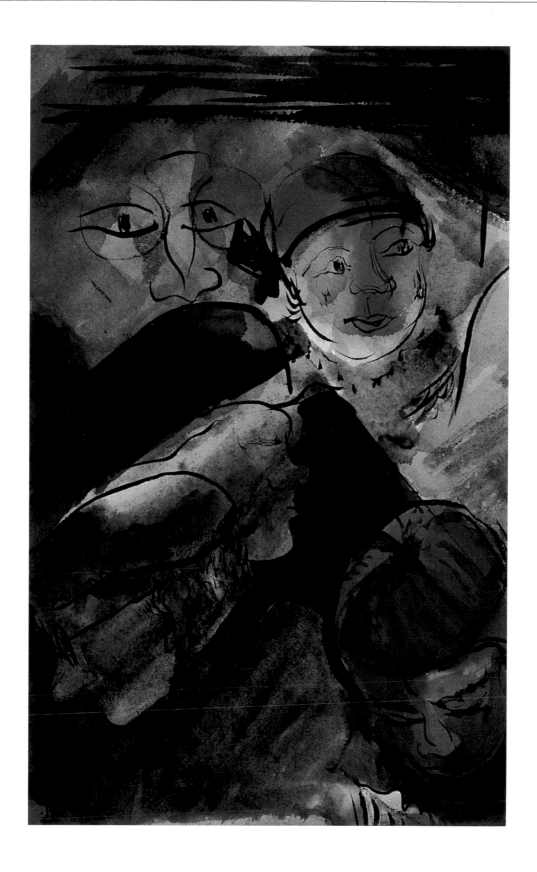

29. *Their Dilemma*, 1960

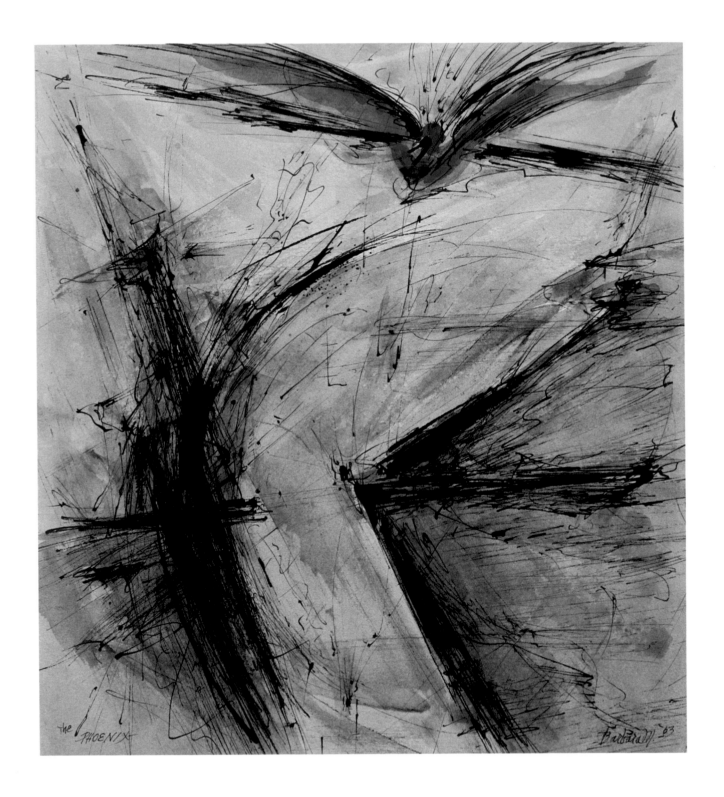

30. *The Phoenix*, 1963

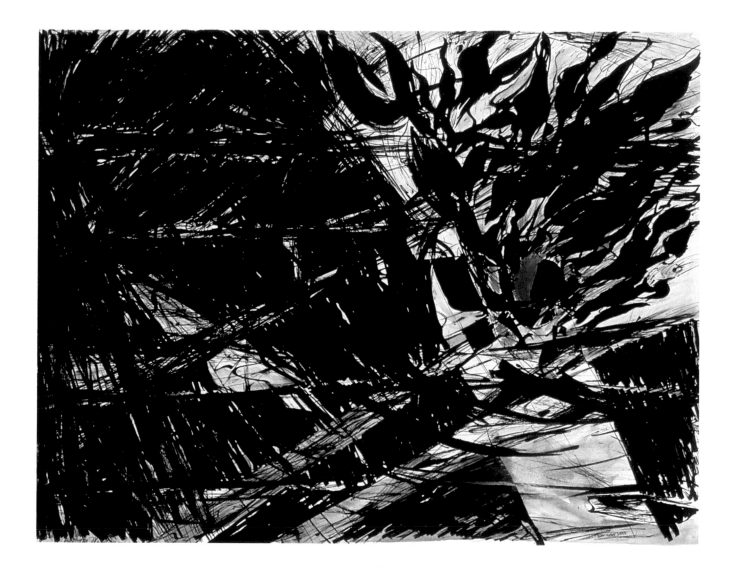

22. *Sun Canyon*, 1961

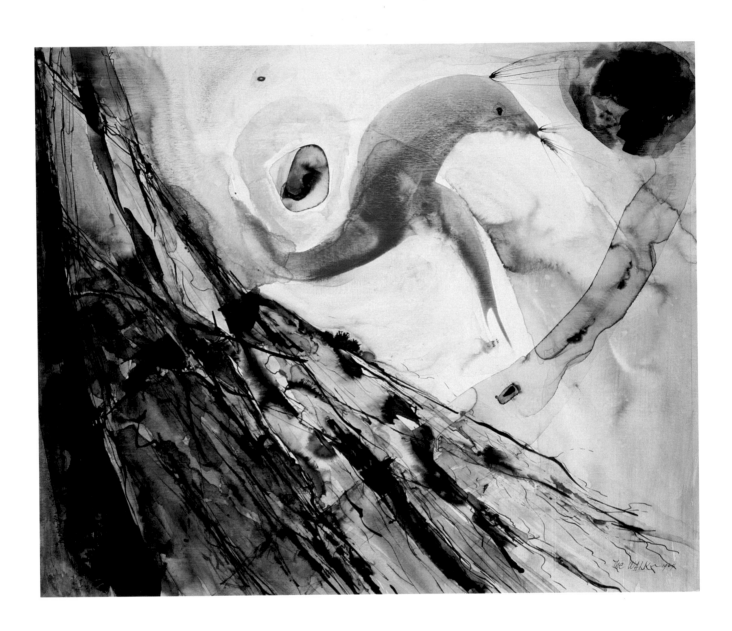

32. *The Walk*, 1964

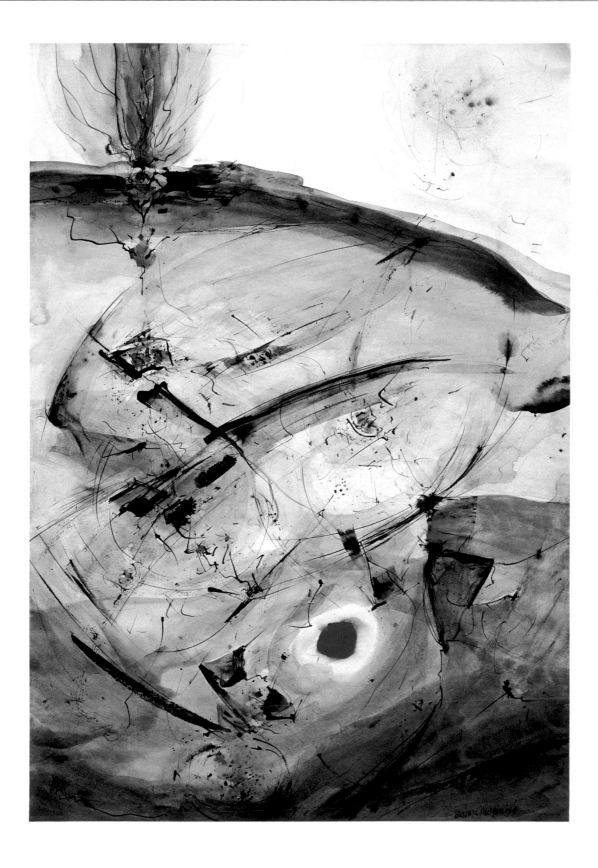

31. *Untitled*, 1964

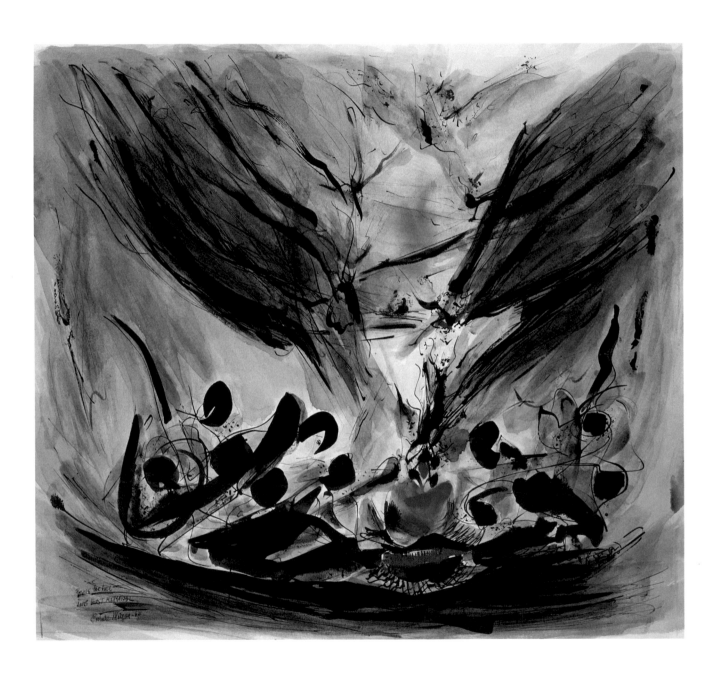

33. *Passing the Torch*, 1964

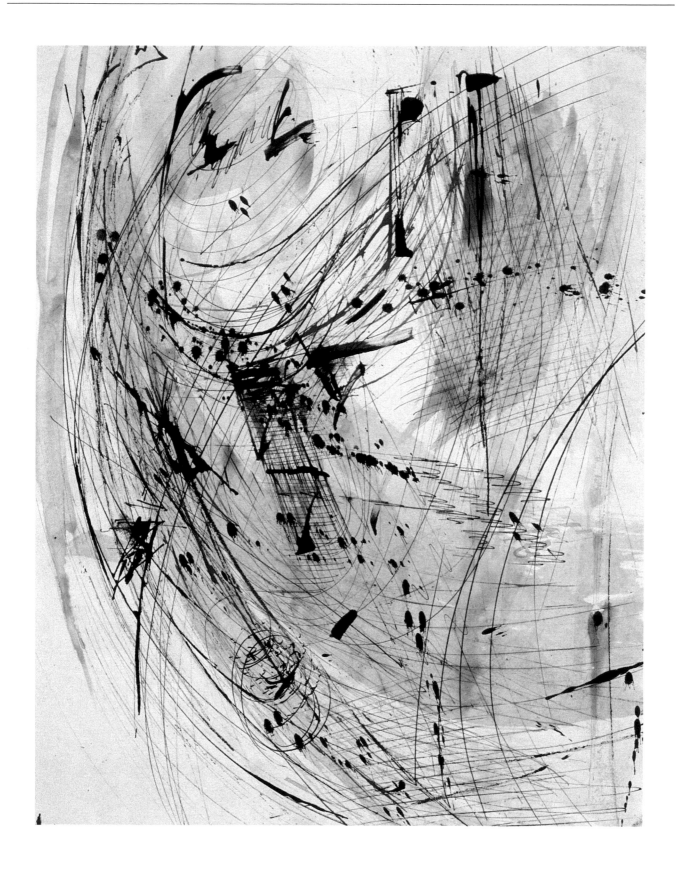

34. *Untitled*, 1967

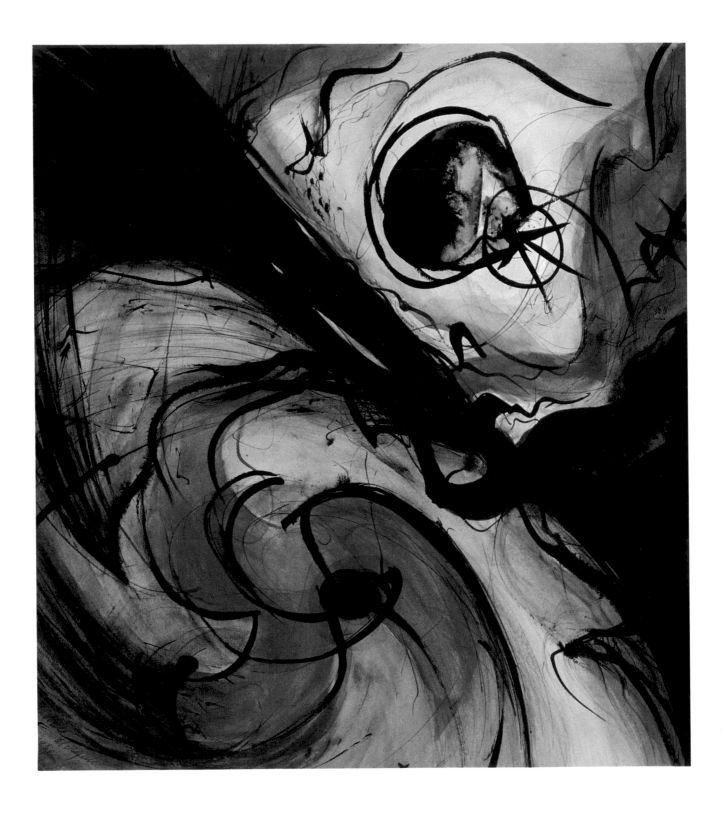

35. *Untitled*, 1969

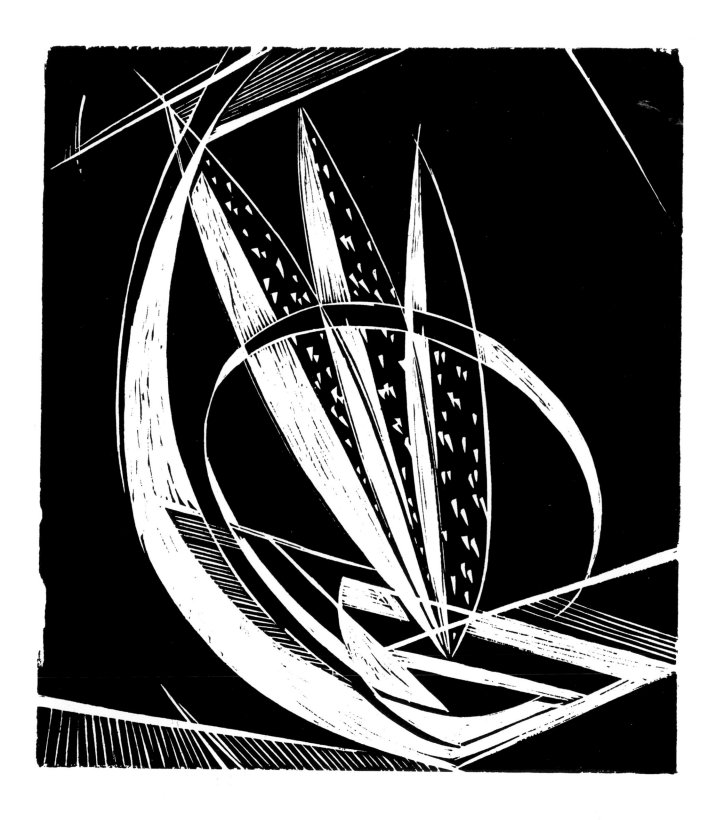

4. *Abstraction*, 1930

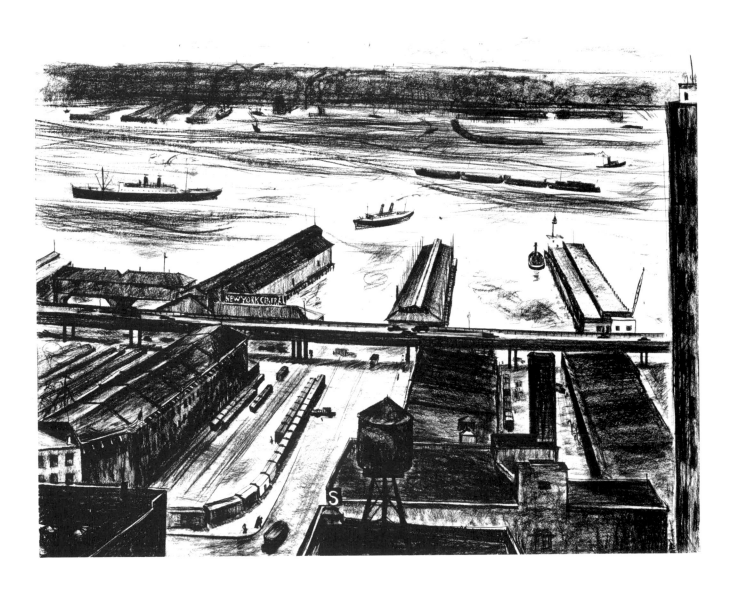

14. *New York Hudson River, 1934*

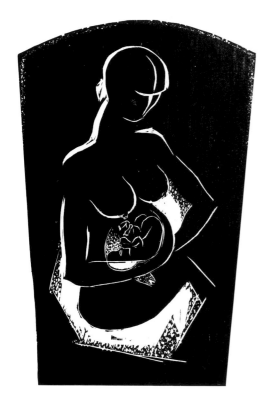

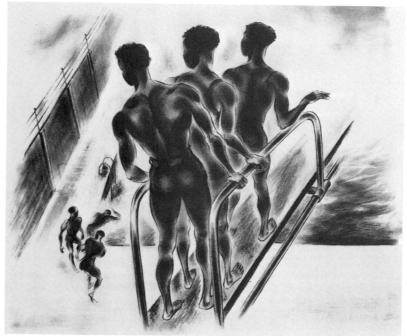

8. *Growing*, 1932

10. *Divers-Harlem Pool*, 1934

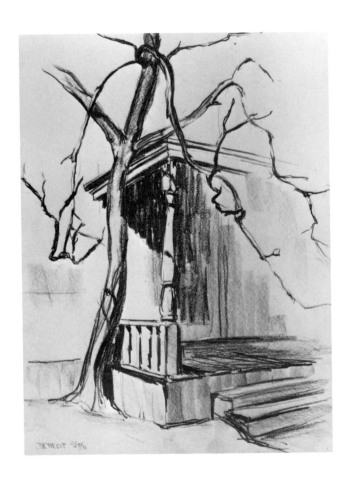

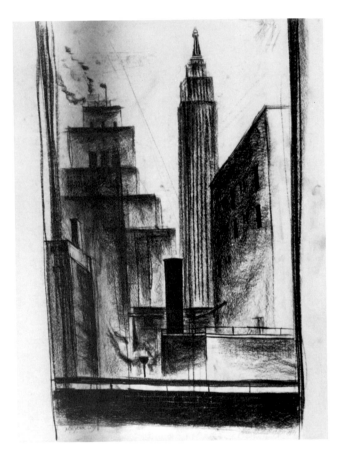

12. *Detroit, 1931* 15. *New York Empire State Building, ca. 1934*

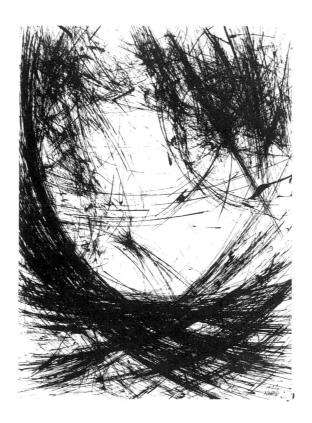

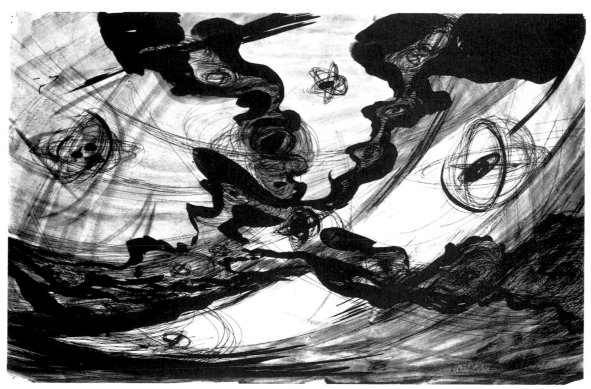

Top: 17. *Untitled,* 1960 Bottom: 23. *Cosmic Monkey Business,* 1953

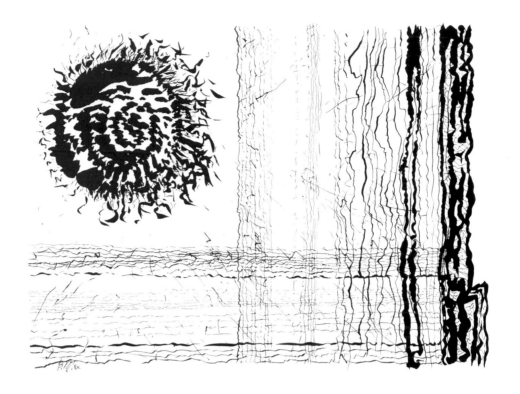

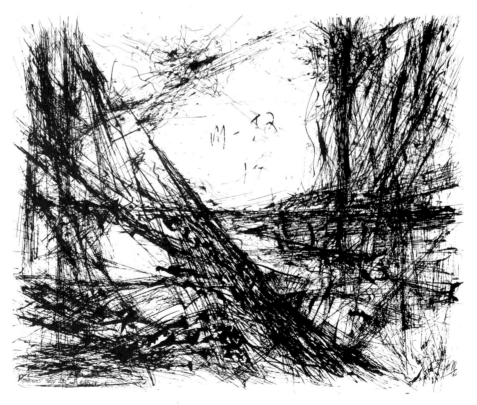

18. *Vibrations Through Air and Earth, 1960* 19. *Orbital Episode, 1960*

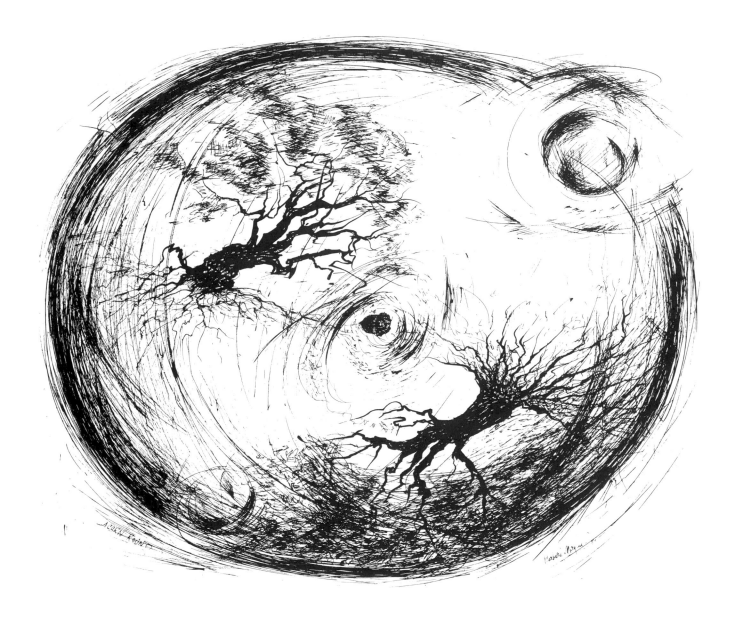

20. *Acorn Round,* 1961

Photomontage

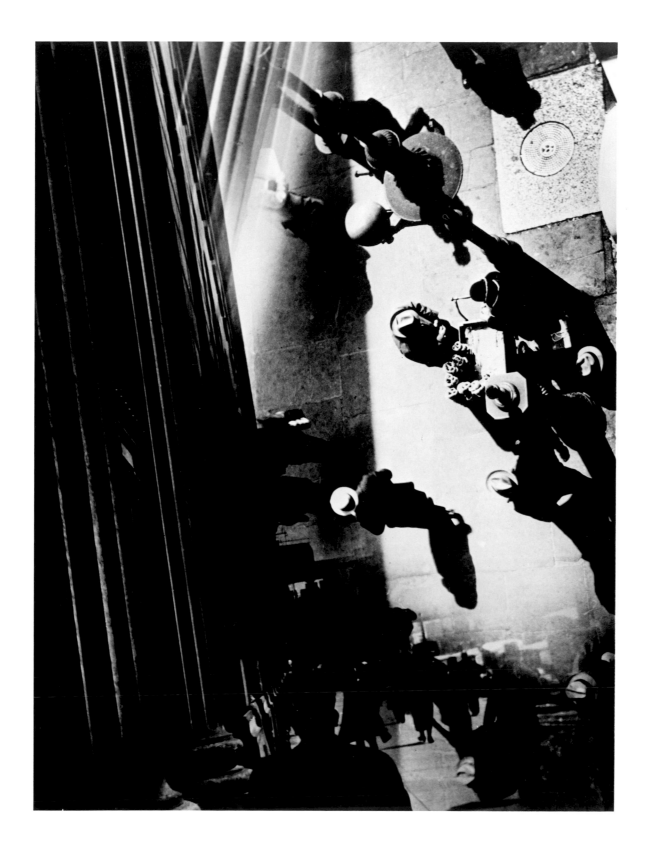

43. *City Street*, 1937

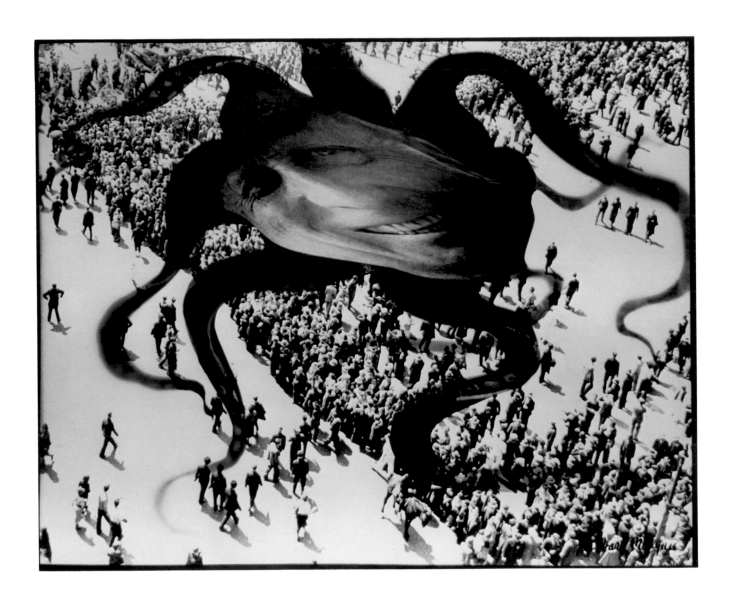

44. *Hearst Over the People*, 1939

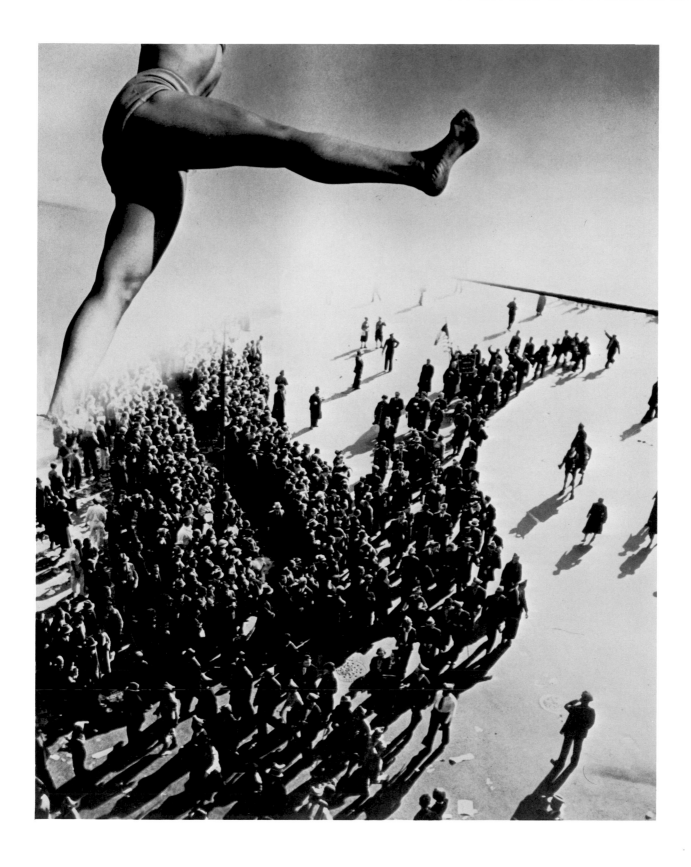

47. *Protest*, 1940

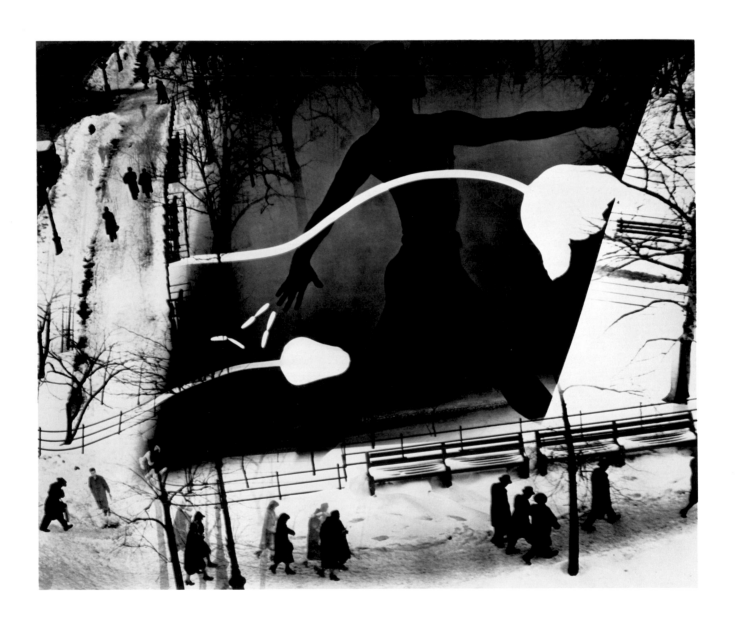

45. *Spring on Madison Square, 1938*

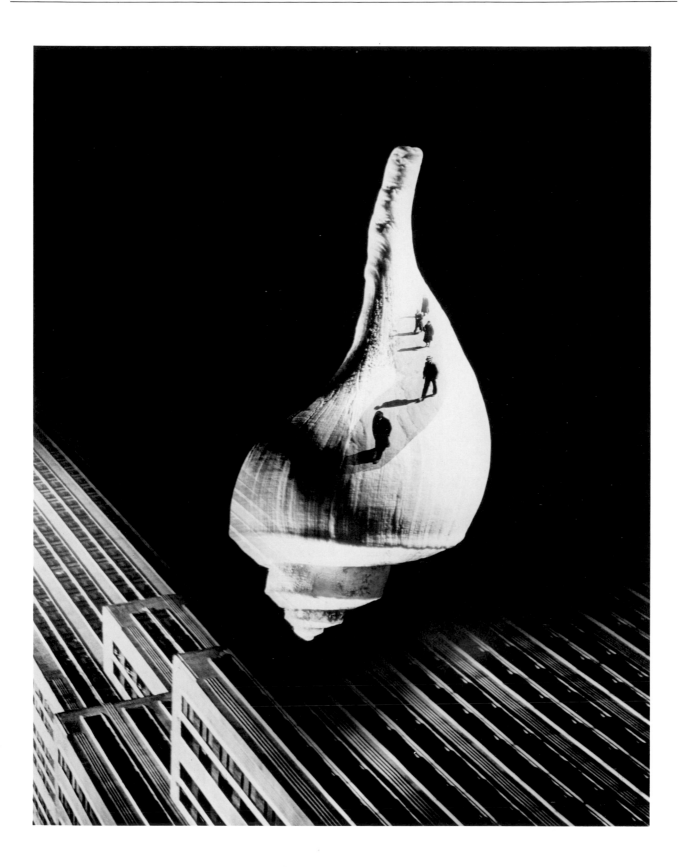

46. *City Shell*, 1938

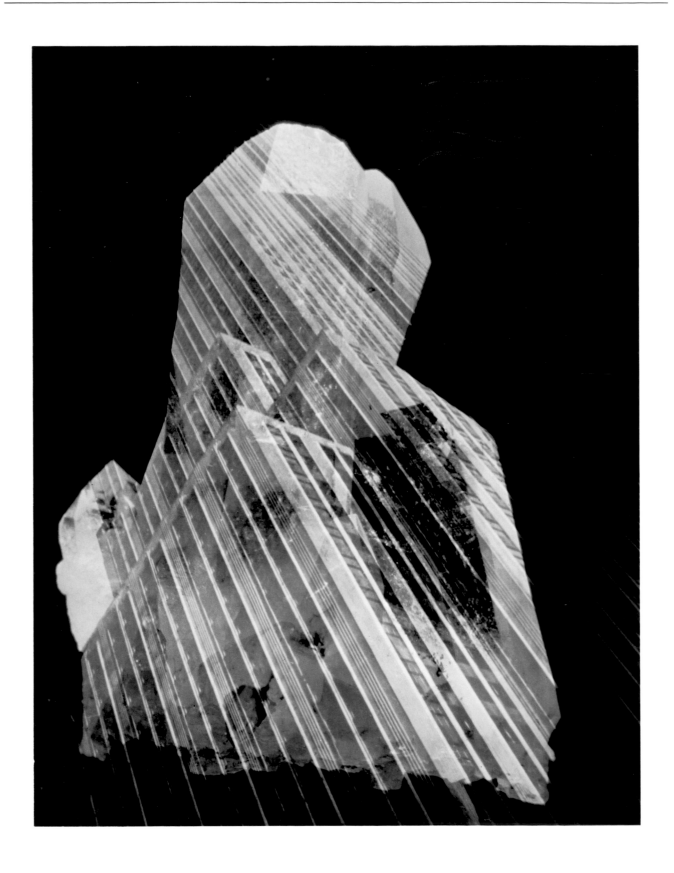

52. *Crystallized Skyscraper*, 1973

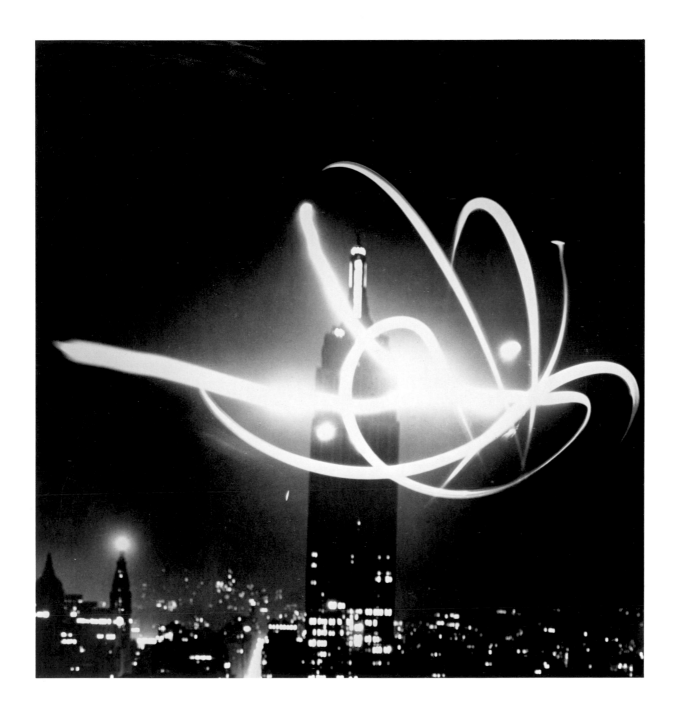

51. *UFO Visits New York*, 1965

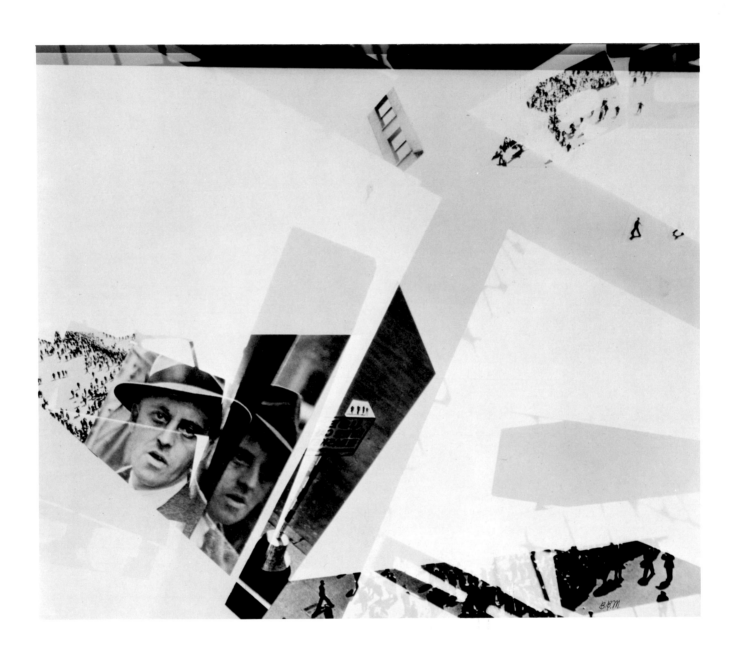

48. *Use Litter Basket*, 1943

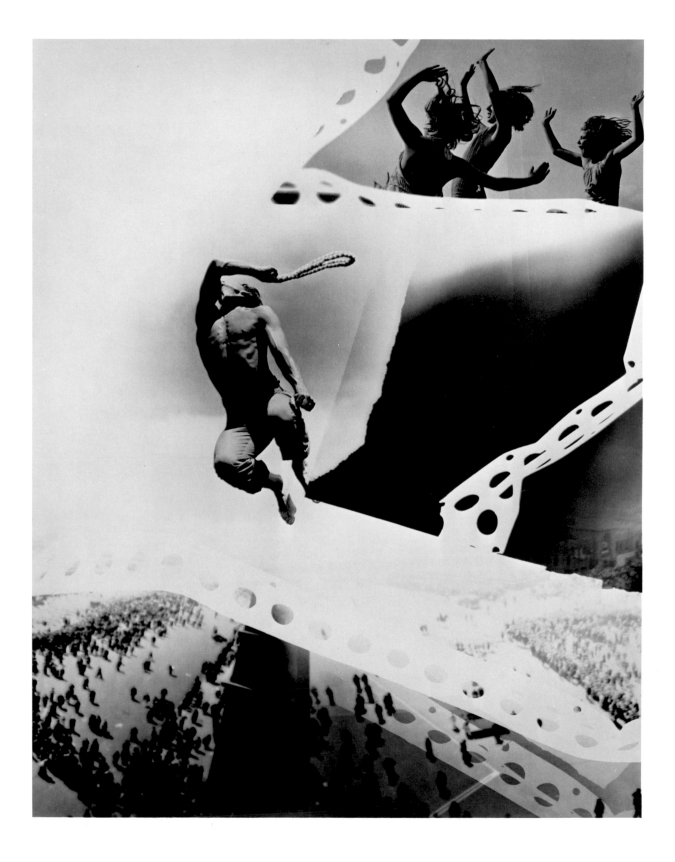

49. *Hullabaloo,* 1959

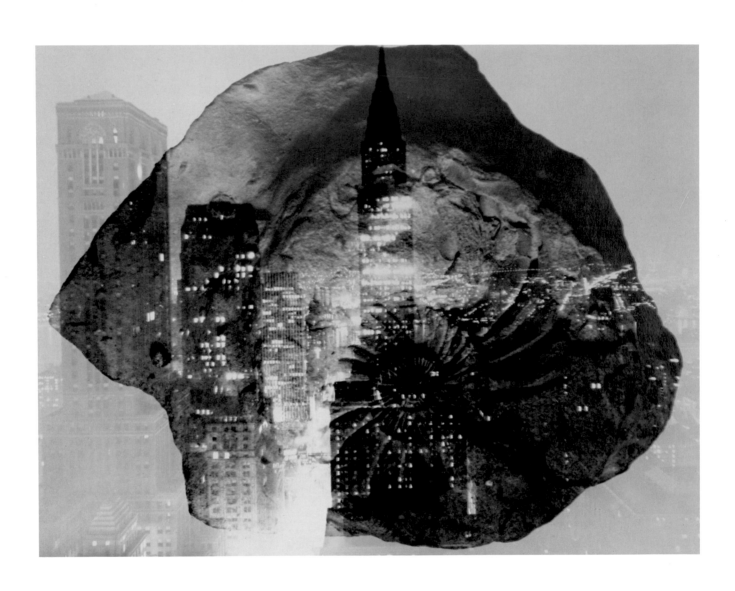

50. *Fossil In Formation*, 1965

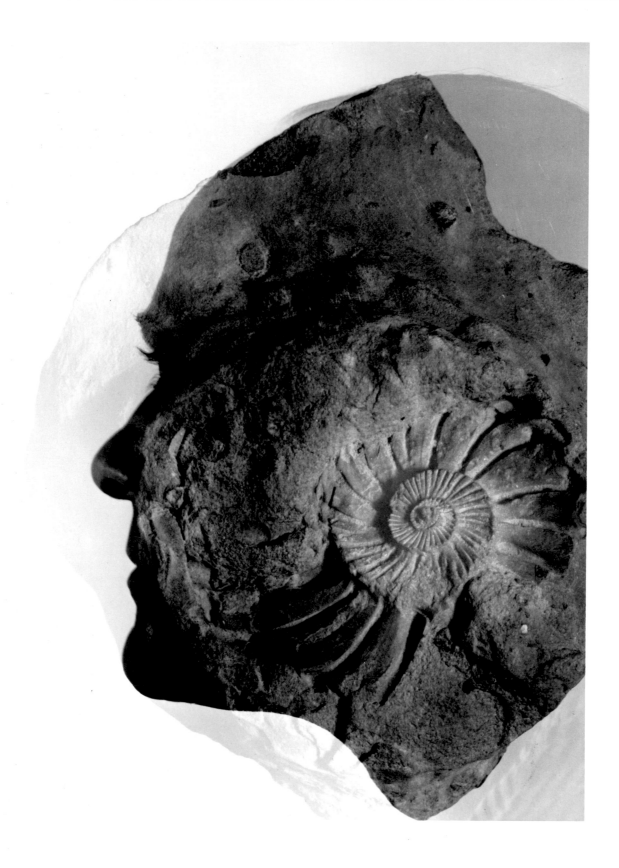

53. *Nuclear Fossilization*, 1979

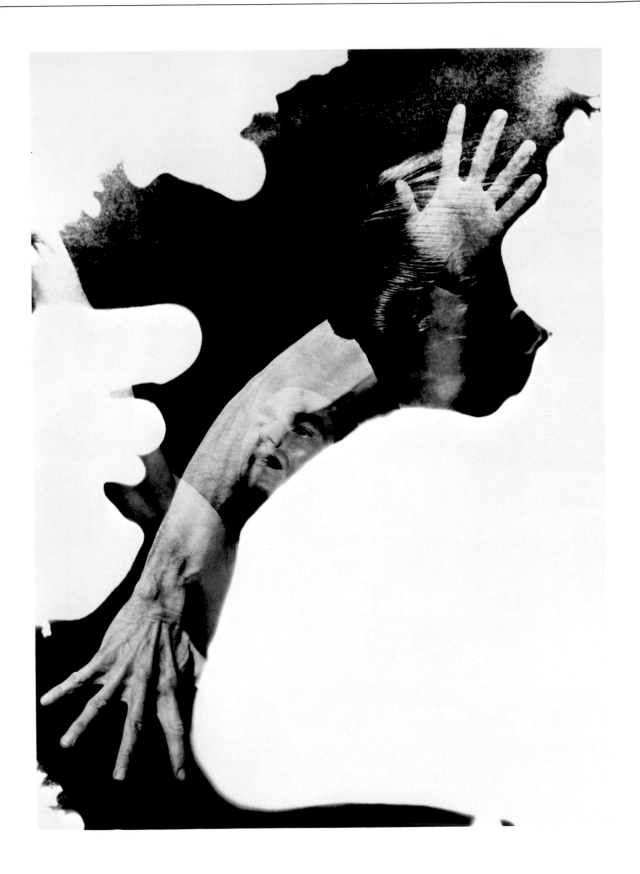

54. *Searching*, 1979

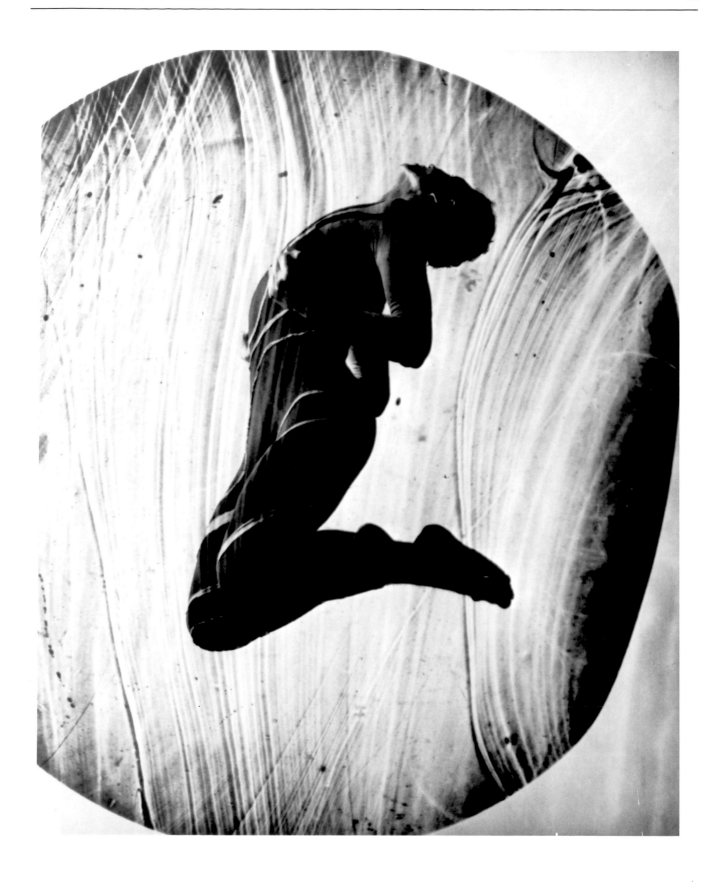

55. *Emergence,* 1979

Light Drawings

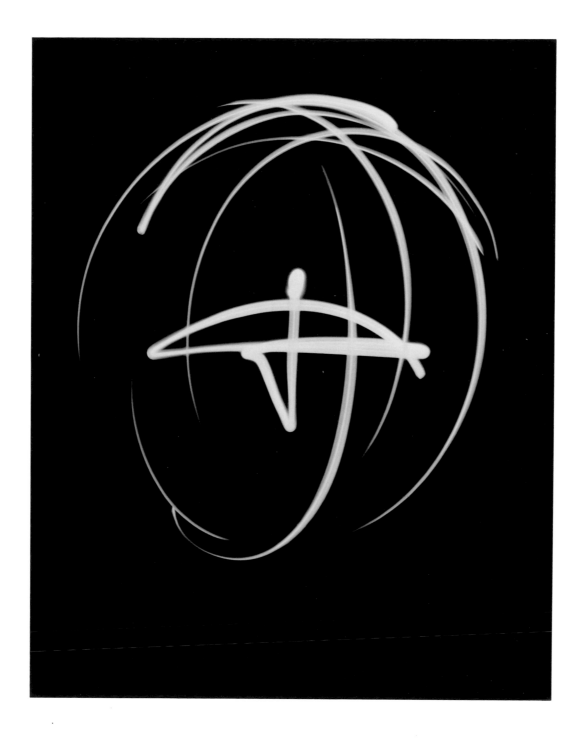

56. *Samahdi*, 1940

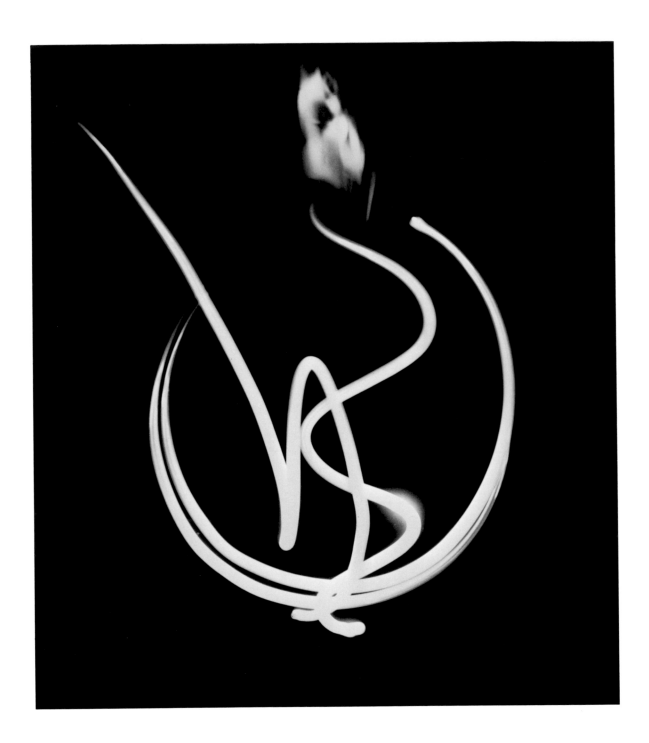

57. *Cadenza,* 1940

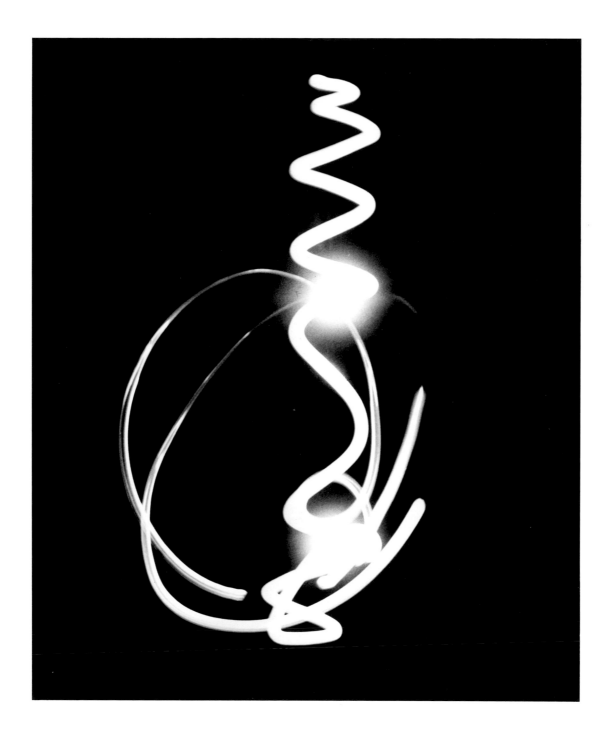

58. *Emanation I*, 1940

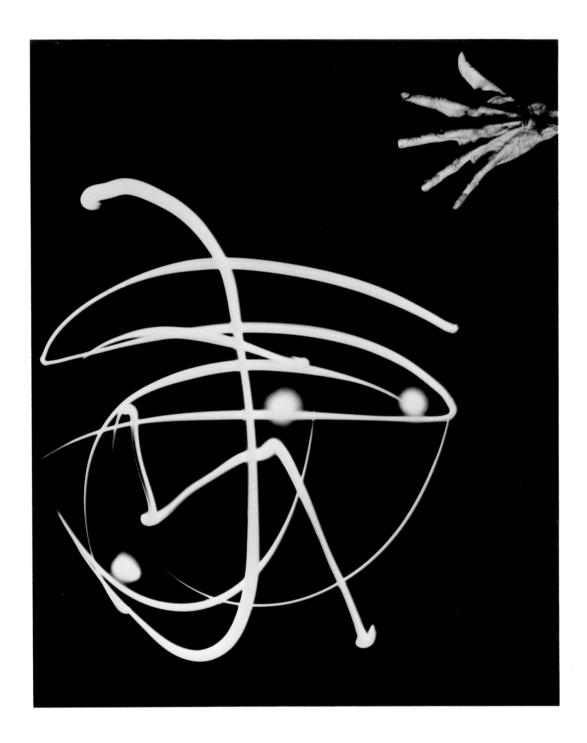

59. *Pure Energy and Neurotic Man*, 1941

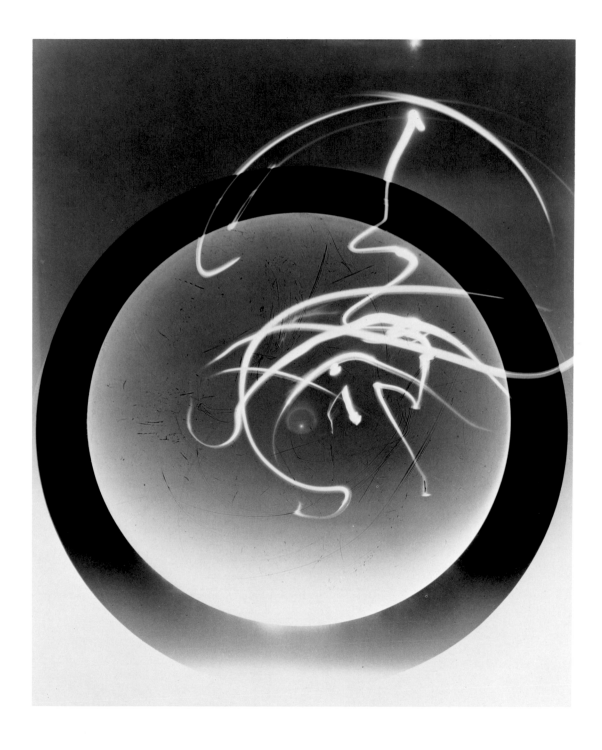

60. *Cosmic Effort*, 1965

Dance

62. Martha Graham, *"Ekstasis,"* 1935

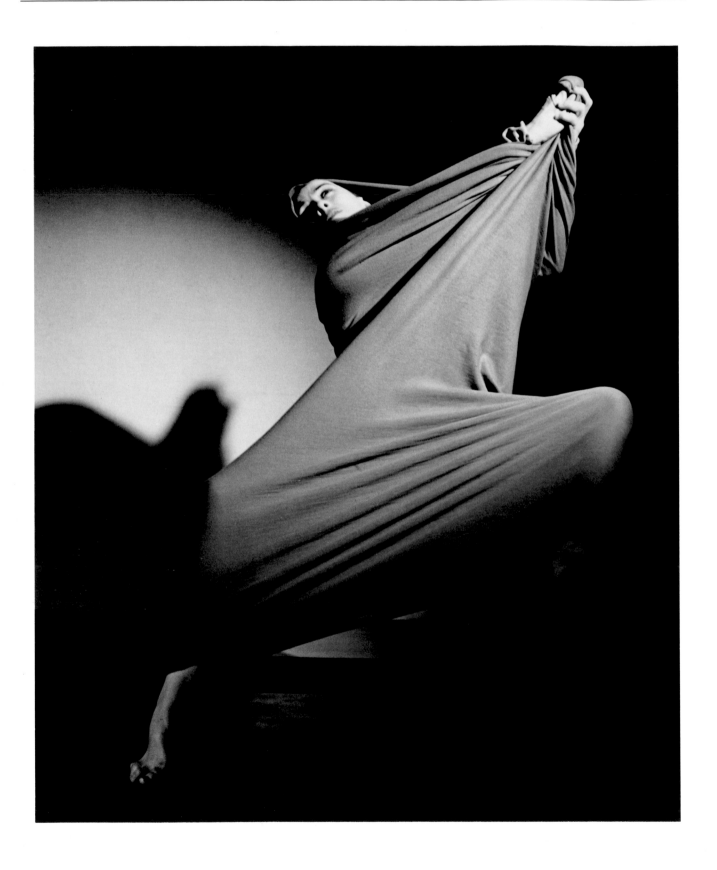

63. Martha Graham, *"Lamentation,"* 1935

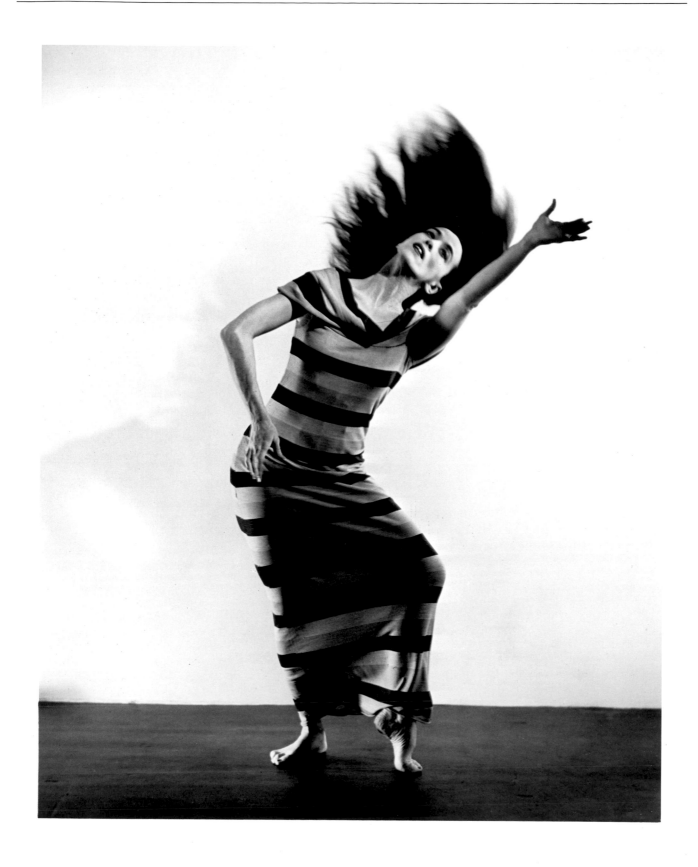

61. Martha Graham, *"Satyric Festival,"* 1935

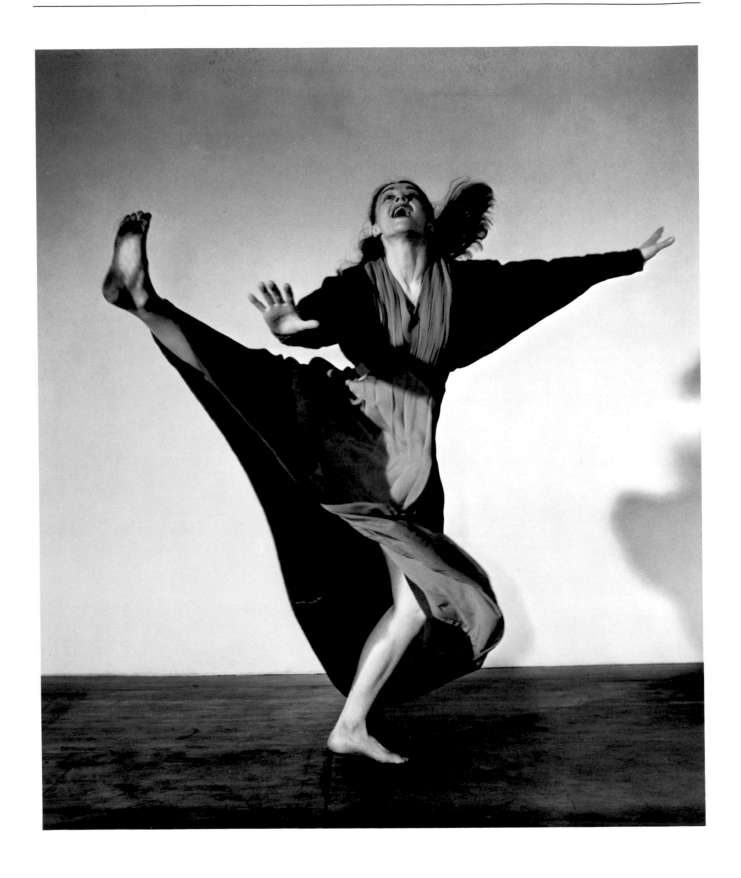

68. Louise Kloepper, *"Statement of Dissent,"* 1938

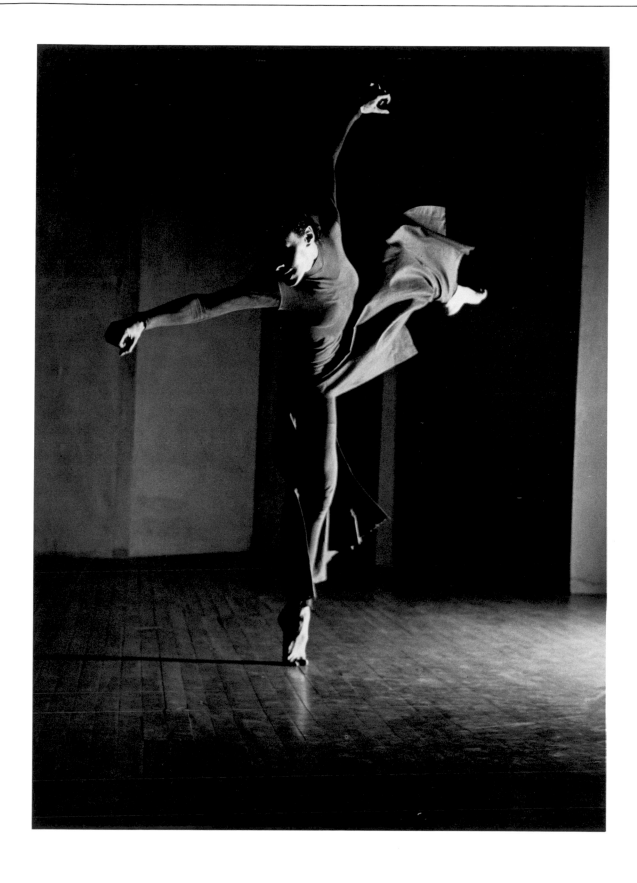

64. Charles Weidman, *"Lynchtown"* (Bea Seckler solo), 1938

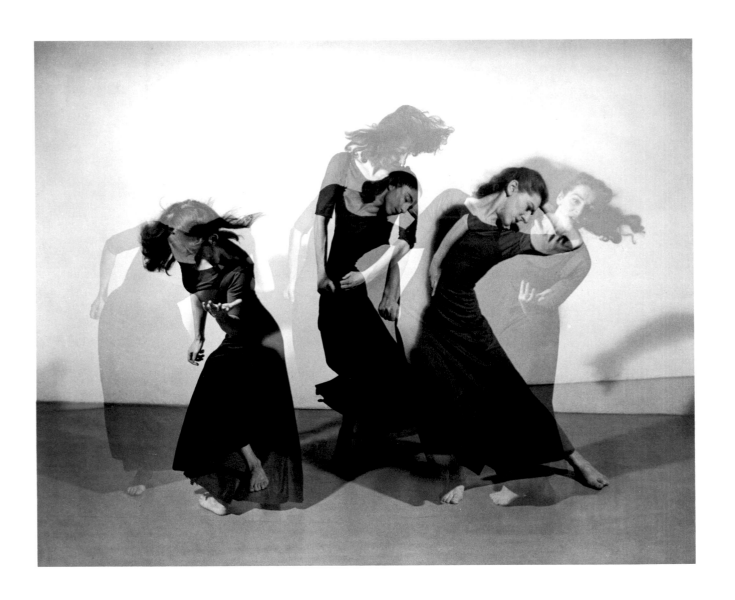

66. Martha Graham, *"American Document"* (trio), 1938

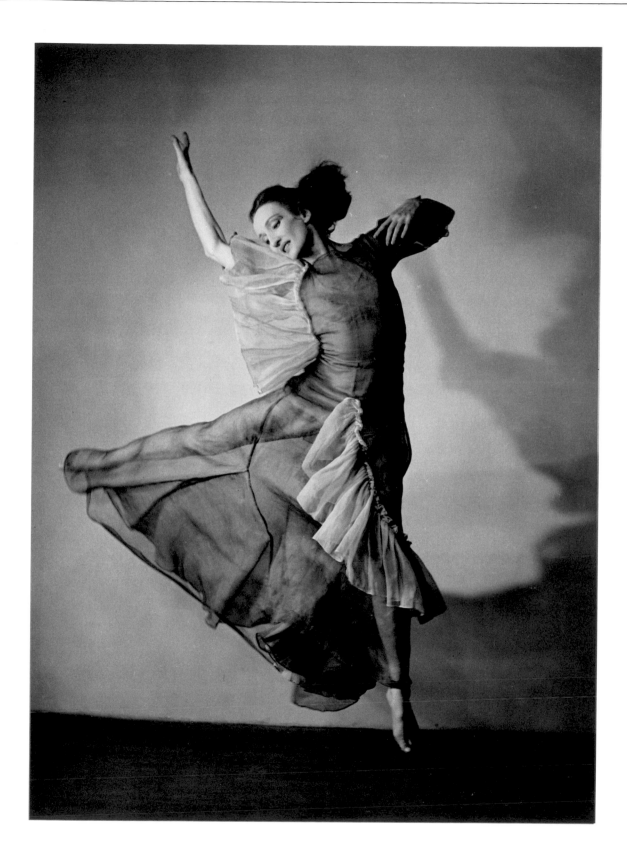

67. Doris Humphrey, *"Square Dance for Moderns"* (waltz), 1938

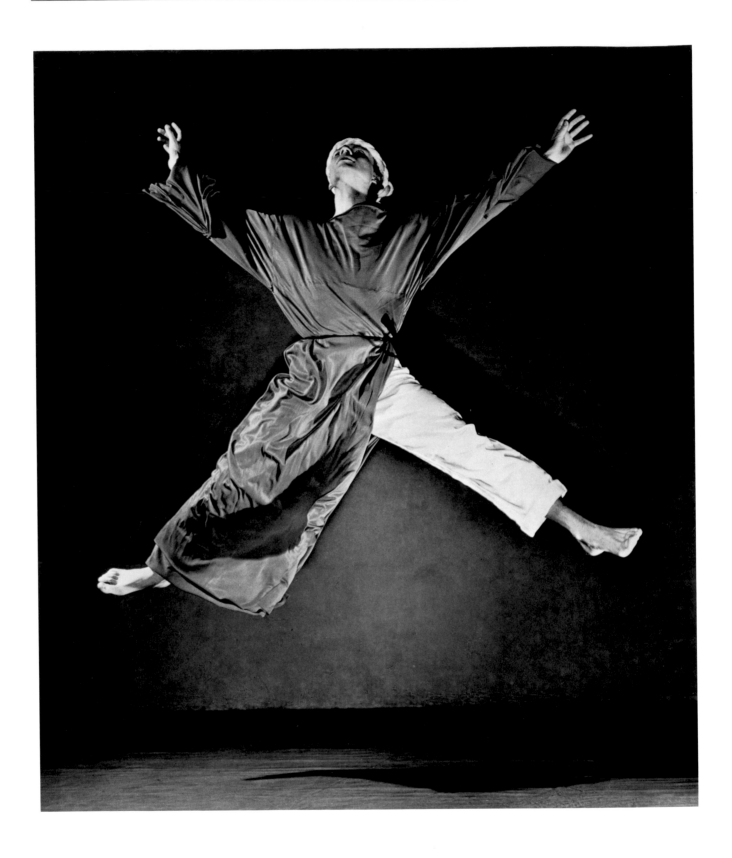

70. Martha Graham, *"El Penitente,"* Merce Cunningham, 1940

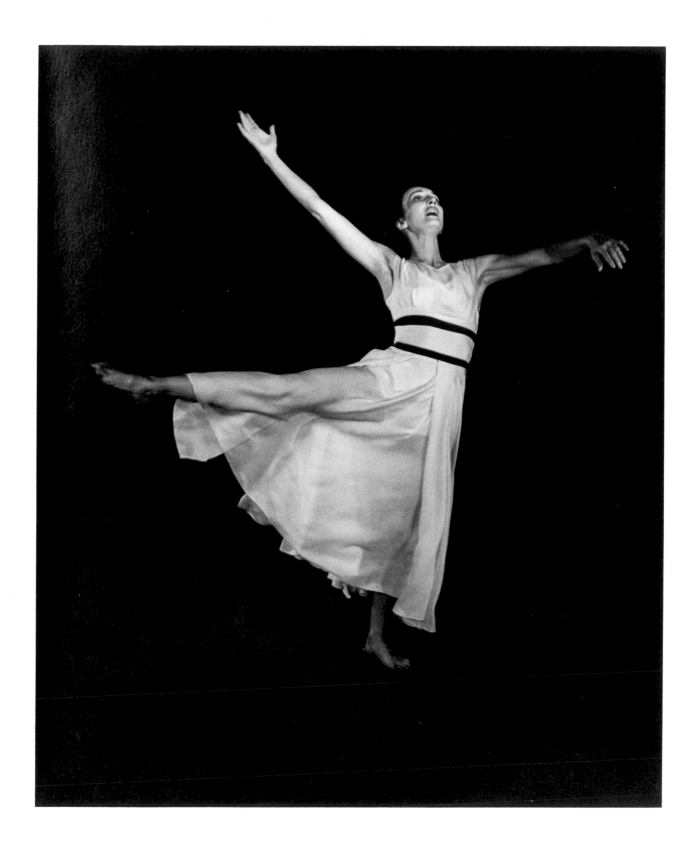

65. Doris Humphrey, *"Passacaglia,"* 1938

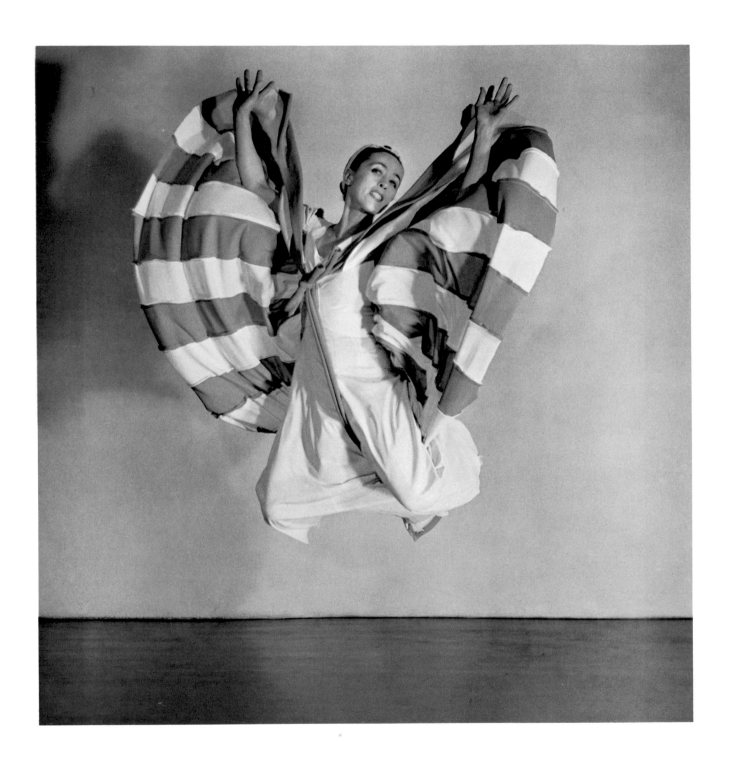

69. Martha Graham, *"Every Soul is a Circus,"* 1940

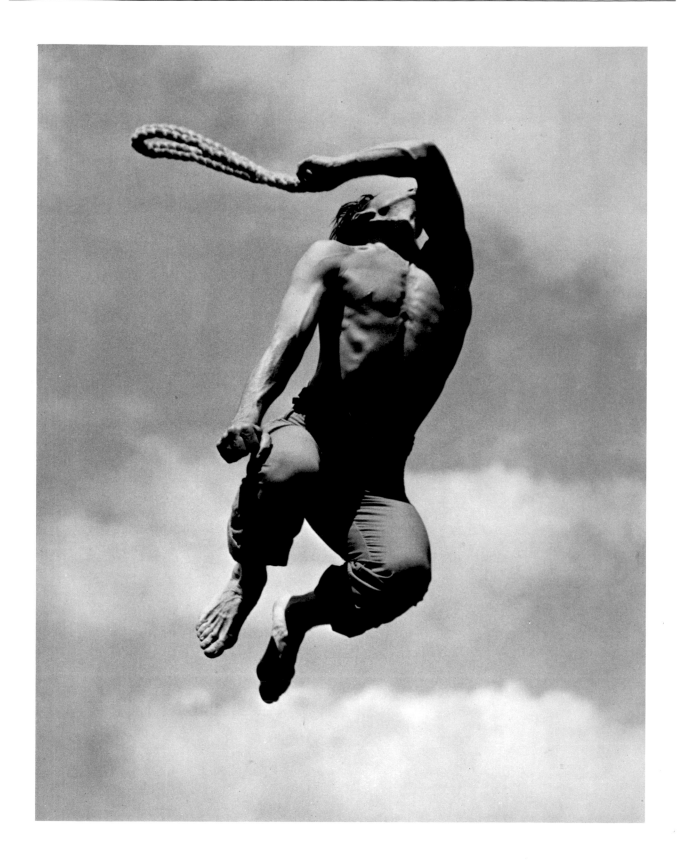

72. Martha Graham, *"El Penitente,"* Erick Hawkins, 1940

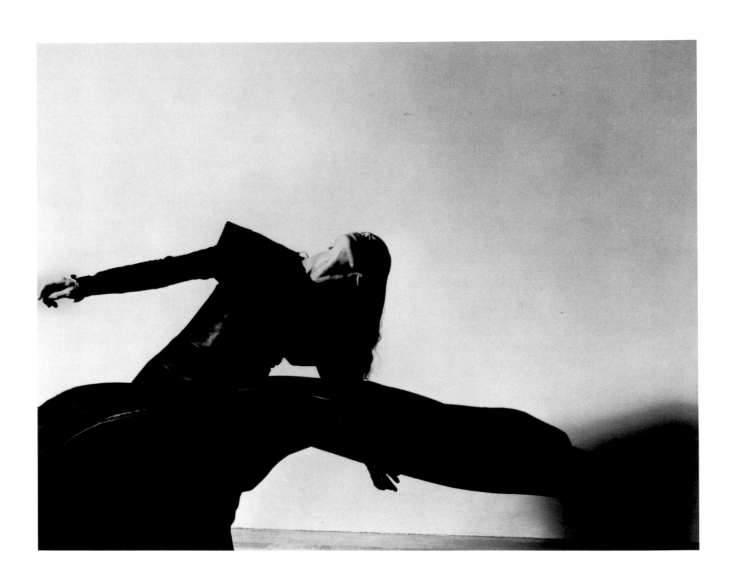

73. Martha Graham, *"War Theme,"* 1941

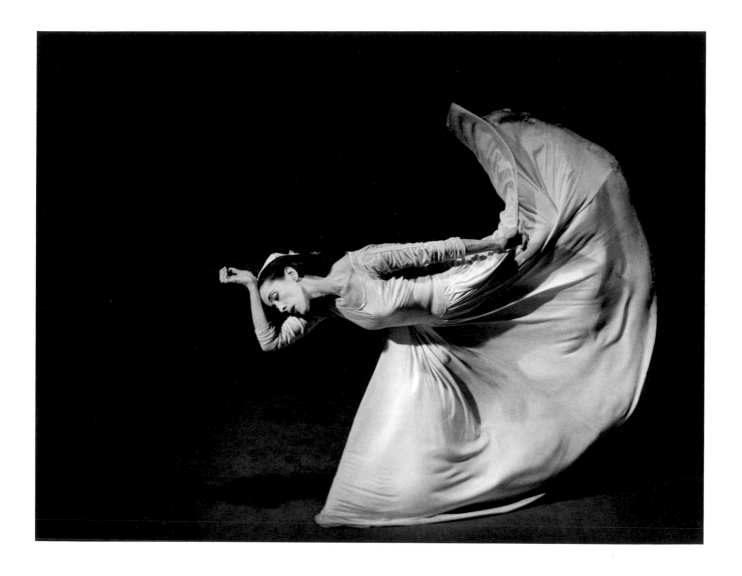

71. Martha Graham, *"Letter to the World,"* 1940

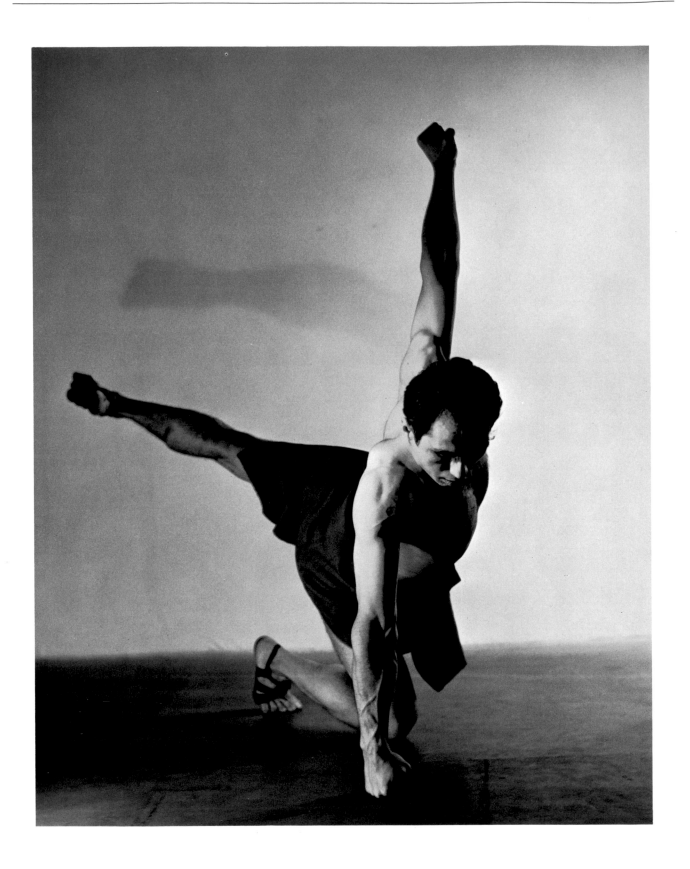

79. José Limón, *"Mexican Suite"* (Indian), 1944

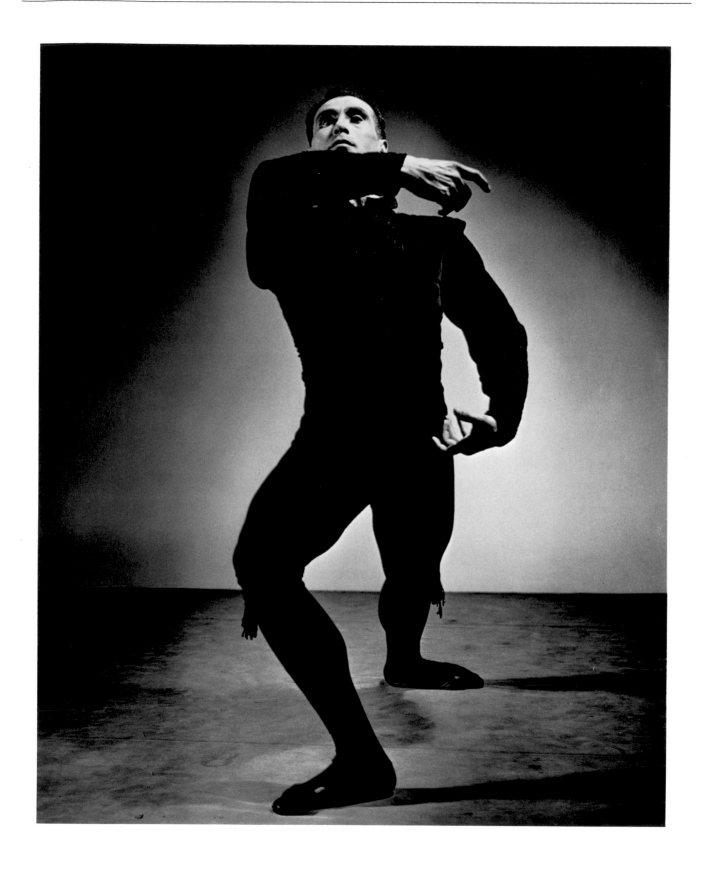

77. José Limón, "*Chaconne*," 1944

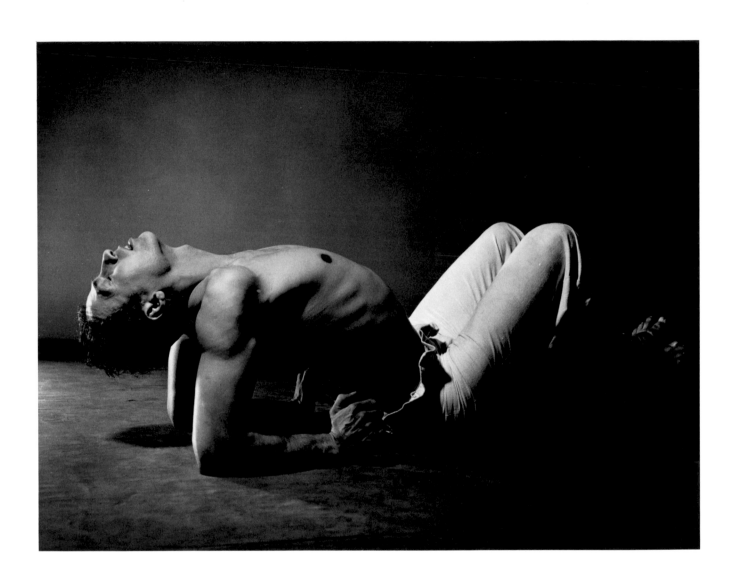

78. José Limón, *"Mexican Suite"* (peon), 1944

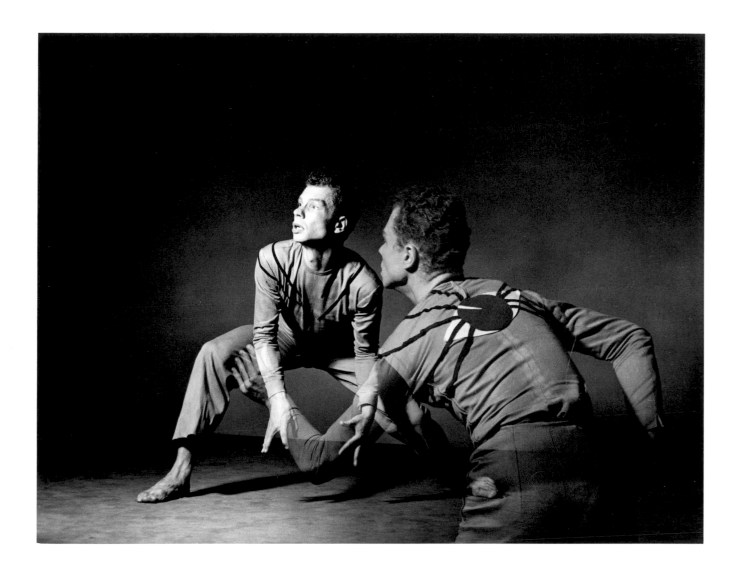

76. Merce Cunningham, *"Root of the Unfocus,"* 1944

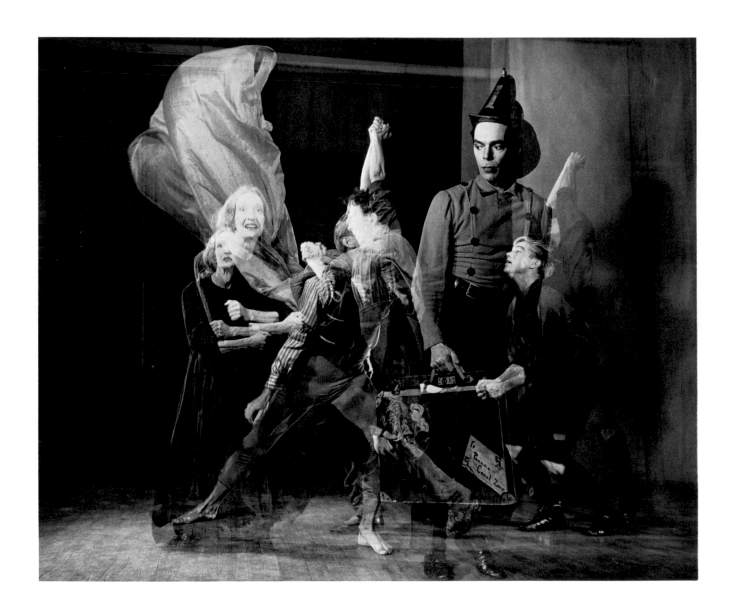

74. Doris Humphrey-Charles Weidman, *"Rehearsal Nightmare,"* 1944

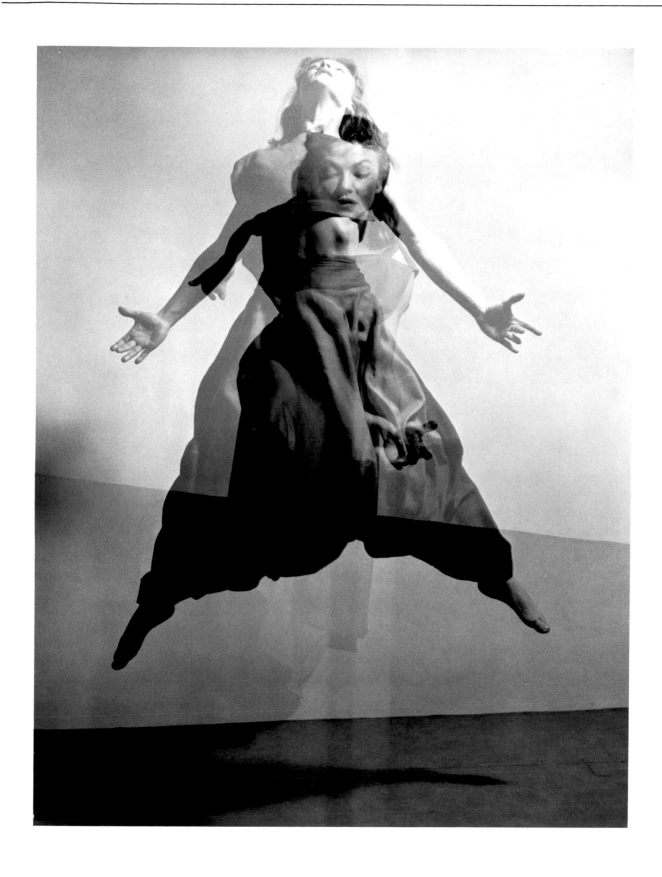

75. Valerie Bettis, *"Desperate Heart,"* 1944

Nature & People

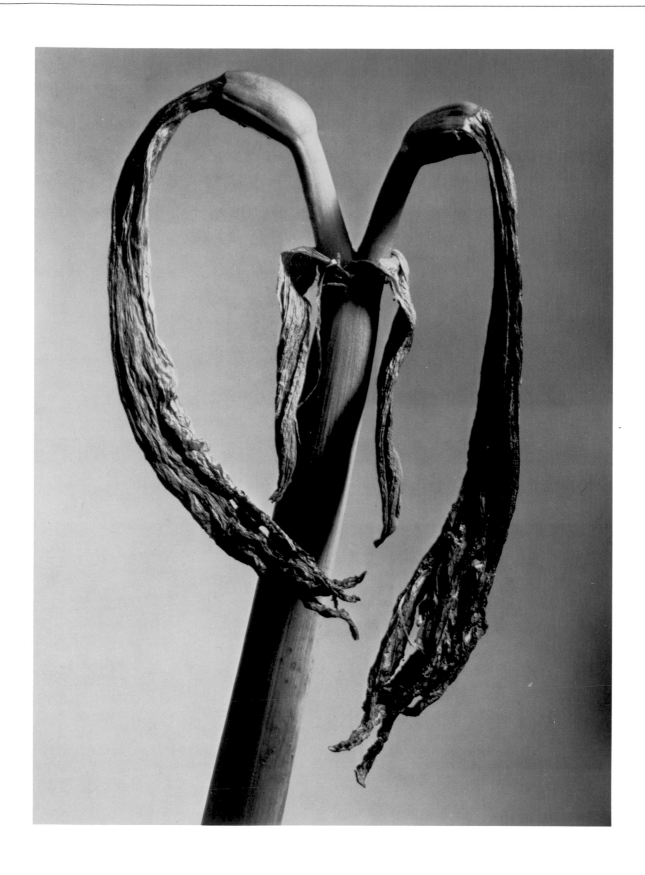

85. *Amaryllis*, 1943

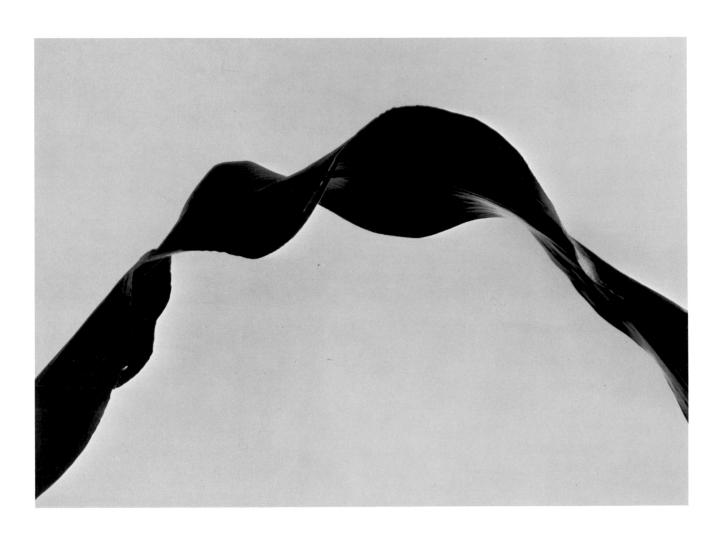

86. *Corn Leaf Rhythm,* 1947

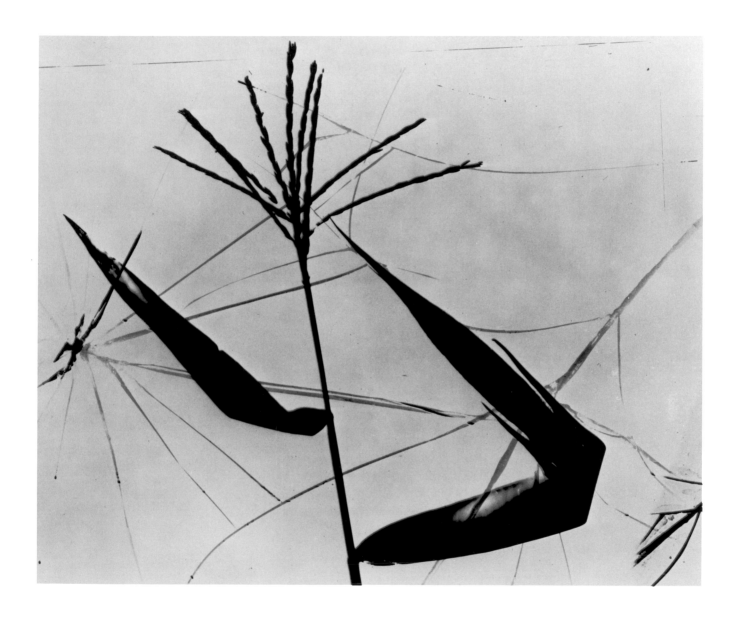

93. *Corn Tassel Through Broken Window, 1967*

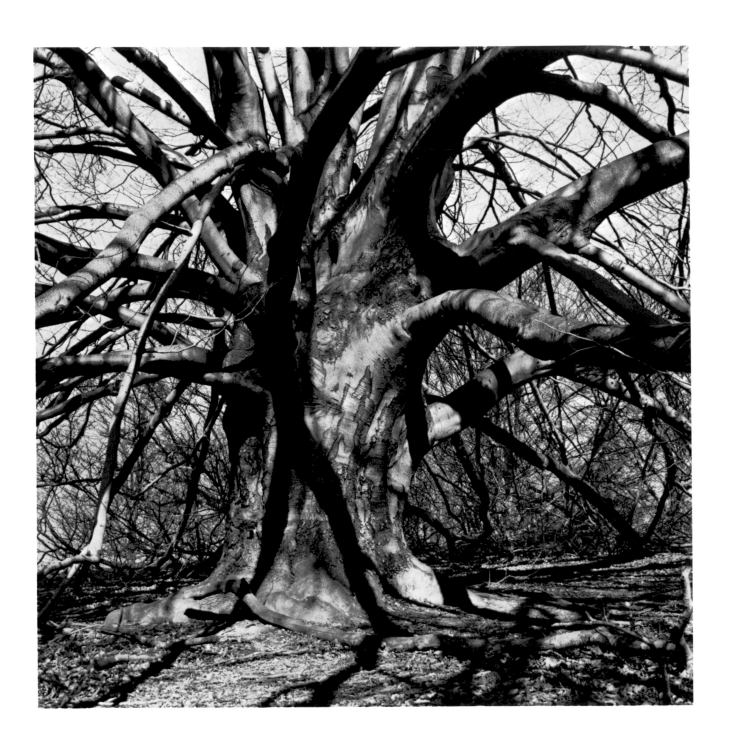

88. *Beech Tree IV*, 1945

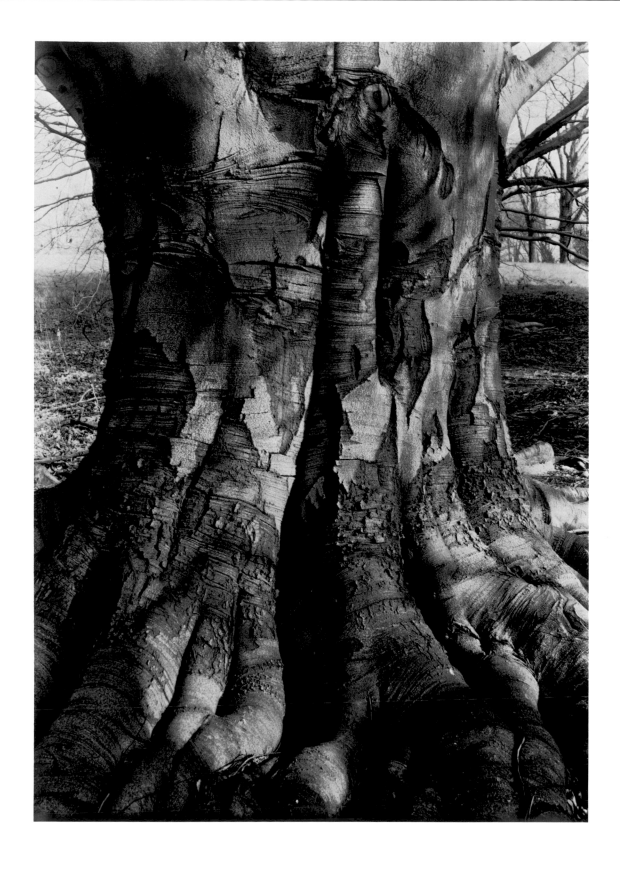

87. *Beech Tree I*, 1945

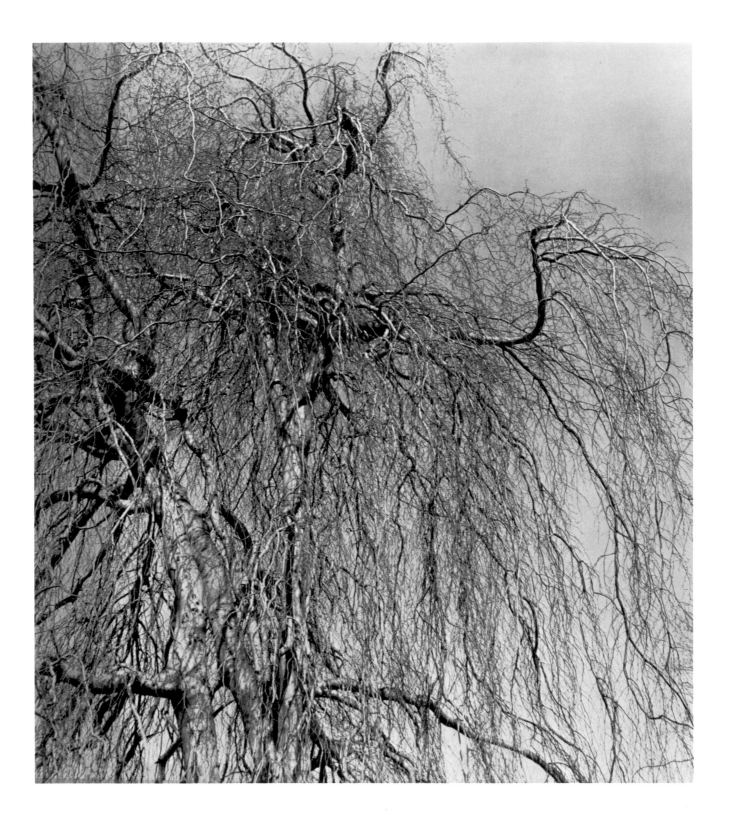

91. *Delicate Beech*, 1945

92. *Resurrection in the Junkyard*, 1947

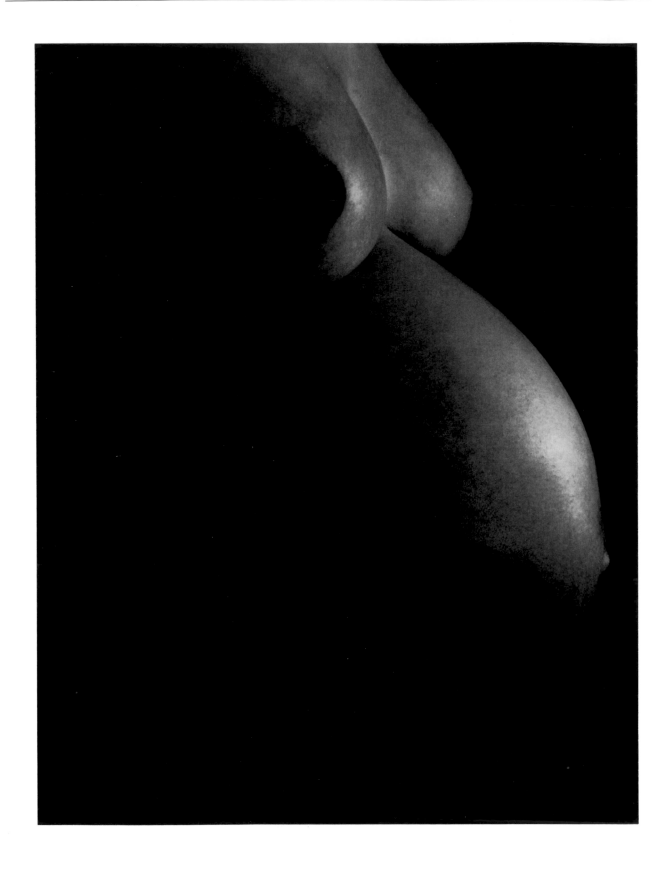

84. *Pregnant*, 1940

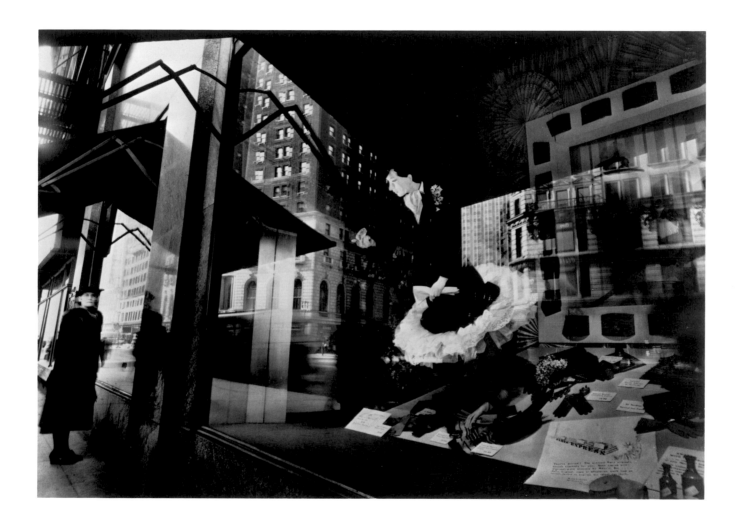

83. *Macy's Window, 1939*

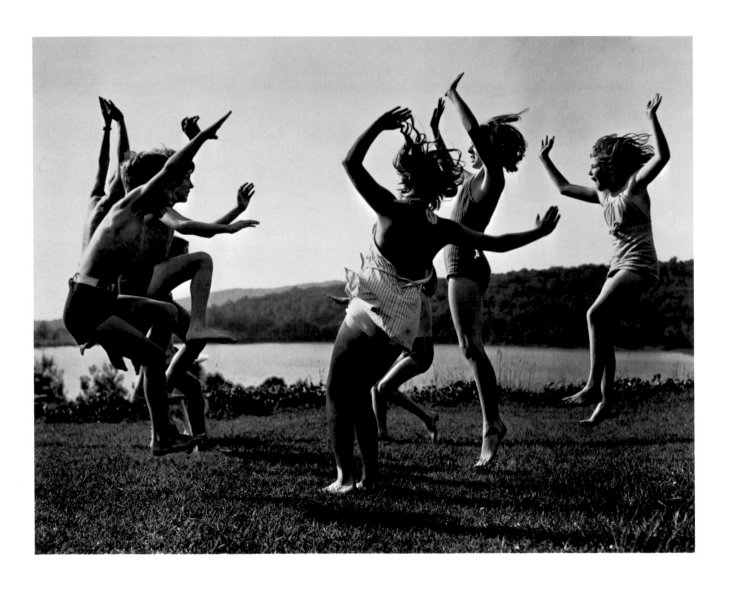

90. *Children Dancing by the Lake, 1940*

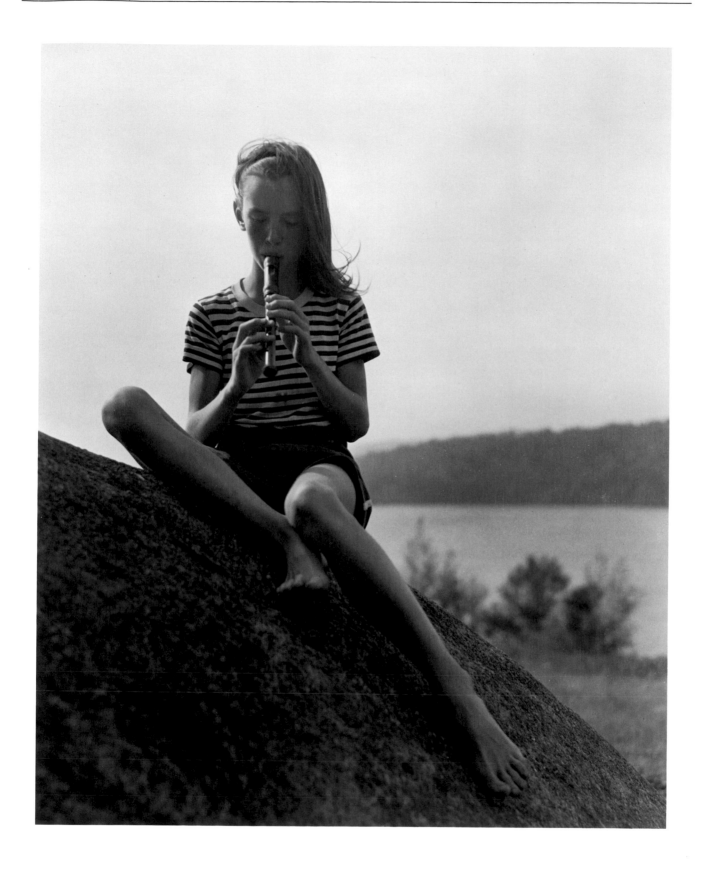

89. *Girl Playing Recorder*, 1945

Chronology

1900 Born Barbara Brooks Johnson on July 8 in Buffalo, Kansas. Same year family moved to West Coast. Grew up on peach ranch in Southern California.
1919-1923 Student, University of California at Los Angeles (U.C.L.A.), majoring in art.
1923-1924 Taught art in San Fernando High School, San Fernando, California.
1925 Married Willard D. Morgan.
1925-1930 Joined art faculty, UCLA. Taught design, landscape, and woodcut. Published *Block Print Book*, containing work of woodcut students. Served variously as writer, managing editor, and editor for *Dark and Light* Magazine, Arthur Wesley Dow Association, UCLA. Painted and photographed in the Southwest with Willard in the summers. Met Edward Weston and realized photography as a medium for artistic expression.
1930 Moved to New York City. Traveled for Willard's Morgan's Leica Lectures. For study, photographed Barnes Foundation art collection, Merion, Pennsylvania.
1931 Established a studio in New York for painting and lithography. Exhibited graphics at Weyhe Gallery, New York, and other galleries.
1932 Son Douglas born. Continued to exhibit paintings.
1934 One-person painting and graphics exhibition, Mellon Gallery, Philadelphia.
1935 Son Lloyd born. Saw Martha Graham perform "Primitive Mysteries." Began photographing Martha Graham dances.
1935-1941 Photographed, exhibited pictures of city themes, dance, children, photomontages and light drawings.
1941 Moved to Scarsdale, New York. Published book, *Martha Graham: Sixteen Dances in Photographs*. Awarded American Institute of Graphic Arts Trade Book Clinic Award.
1942-1955 Continued photographic projects and exhibitions. Published second book, *Summer's Children: A Photographic Cycle of Life at Camp*. Picture-edited and designed book by Erica Anderson and Eugene Exman, *The World of Albert Schweitzer* (Harper & Row, N.Y., 1955).

1959 Art-archeological trip to Crete, Greece, Spain, Italy, France and England.
1961 One-person painting and graphics exhibition, Sherman Gallery, New York.
1967 Death of Willard D. Morgan.
1968-1988 Prepared major exhibitions and delivered numerous lectures and seminars.
1970 Elected Fellow of the Philadelphia Museum of Art.
1975 Received grant from National Endowment for the Arts.
1977 Created *BARBARA MORGAN DANCE PORTFOLIO*.
1978 Received honorary Doctorate of Fine Arts, Marquette University, Milwaukee.
1978 Included in book and exhibit, *RECOLLECTIONS: Ten Women of Photography*, International Center of Photography, New York.
1988 Awarded Lifetime Achievement Award by American Society of Magazine Photographers, Washington, D.C.

Selected List of Solo Exhibitions

1938 "Dance Photographs," Y.M.H.A., Lexington Ave., New York, N.Y.
1939 "Dance Photographs," University of Minnesota, Minneapolis, Minnesota.
Duke University, Durham, North Carolina.
Kamin Dance Gallery, New York, N.Y.
"A Portfolio of the Dance," Columbia University, New York, New York.
Wheaton College, Norton, Massachusetts.
1940 Black Mountain College, Black Mountain, North Carolina. "Dance Photograph Touring Exhibitions, I, II, III and IV," circulated to over 150 colleges, museums and galleries. Continued until 1943.
"Photographs of the Dance," Photo League, New York, N.Y.
Pratt Institute, Brooklyn, New York.
University of Minnesota, Minneapolis, Minnesota.
1941 Wesleyan University, Middletown, Connecticut.
Baltimore Museum of Art, Baltimore, Maryland.

1943 "Modern Dance in Photography," Carleton College, Northfield, Minnesota.
1944 Black Mountain College, Black Mountain, North Carolina.
"The Dance," First Annual Arts Forum, The Woman's College of the University of North Carolina, Greensboro, North Carolina.
1945 Jewish Community Center, Detroit, Michigan.
"Modern American Dance," Museum of Modern Art, New York, N.Y.. Spanish and Portuguese versions prepared for the Inter-American Office of the National Gallery of Art for circulation in Latin America. Portuguese version shown at United Nations Conference, San Francisco, during first formative session.
1946 University of Redlands, Redlands, California.
University of Minnesota, Minneapolis, Minnesota.
University of Wisconsin, Madison, Wisconsin.
1947 World Youth Festival, Prague, Czechoslovakia.
1952 "Summer's Children," New York Public Library, New York, N.Y.
1955 "Summer's Children," George Eastman House, Rochester, New York.
1956 "Summer's Children," Kodak Photographic Information Center, Grand Central Terminal, New York, N.Y.
1957 *Parents' Magazine* Gallery, New York, N.Y.
1959 Twelfth American Dance Festival, Connecticut College, New London, Connecticut.
1962 Arizona State University, Tempe, Arizona.
1964 George Eastman House, Rochester, New York.
Société Francaise de Photographie, Paris, France.
1965 Carnegie Institute of Technology, Pittsburgh, Pennsylvania.
Ceege Galleries, Los Angeles, California (paintings and photographs).
University of Louisville, Louisville, Kentucky.
1969 Long Island University, Brooklyn Center, Brooklyn, New York.

1970 "Barbara Morgan: Women, Cameras, and Images IV," Smithsonian Institution, Washington, D.C.
Friends of Photography Gallery, Carmel, California.
1971 831 Gallery, Birmingham, Michigan.
Montclair Art Museum, Montclair, New Jersey.
Utah State University, Logan, Utah.
1972 Amon Carter Museum of Western Art, Fort Worth, Texas.
Focus Gallery, San Francisco, California
Museum of Modern Art, New York, N.Y.
1973 King Pitcher Gallery for Contemporary Art, Pittsburgh, Pennsylvania.
Pasadena Museum of Modern Art, California.
1974 Institute of American Indian Arts, Santa Fe, New Mexico.
1976 G. Ray Hawkins Gallery, Los Angeles, California.
831 Gallery, Birmingham, Michigan.
1977 The Gallery at Hastings-on-Hudson, New York.
Marquette University, Milwaukee, Wisconsin.
University of Nebraska, Lincoln, Nebraska.
Rochester Institute of Technology, Rochester, New York
1978 Williams College, Museum of Art, Massachusetts.
American Dance Guild, New York, N.Y.
1979 Photographics Workshop, New Canaan, Connecticut.
Ohio University College of Fine Arts, Athens, Ohio.
Baldwin Street Gallery, Toronto, Ontario.
1980 George Eastman House, Rochester, New York (Travelling exhibition widely shown, including Tokyo.)
Douglas Elliott Gallery, San Francisco, California
1981 Ikona Photo Gallery, Venice, Italy
Jeffrey Fuller Gallery, Philadelphia, Pennsylvania
Kathleen Ewing Gallery, Washington D.C.
Zabriskie Gallery, Paris, France
Jane Corkin Gallery, Toronto, Ontario
Bruce Museum, Greenwich, Connecticut
Daniel Wolf Gallery, New York, N.Y.
1982 Arizona State University, Tempe, Arizona.
1983 Catskill Center for Photography, Woodstock, New York.
Syracuse University, New York.
1984 Queensborough Community College, New York.
Hudson River Museum, Yonkers, New York.
1985 University of Oregon, Eugene, Oregon.
Chrysler Museum, Norfolk, Virginia.
1986 Philadelphia Museum of Art, Pennsylvania
Atlanta Ballet Co., Atlanta, Georgia.
1988 Marquette University, Milwaukee, Wisconsin.

Selected List of Articles by Barbara Morgan

1938 "Photomontage," *Miniature Camera work*, Morgan & Lester, New York, 1938, pp. 145-166, ill.
1940 "Photographing the Dance," *Graphic Graflex Photography*, Morgan & Lester, New York, 1st ed., 1940, pp. 230-239, ill.
1941 "Dance Into Photography," *U.S. Camera*, Dec. 1941, pp. 102 and following.
1942 "Dance Photography," *The Complete Photographer*, National Educational Alliance, New York, 18:3, March 10, 1942, pp. 1133-1146, ill.
"In Focus: Photography, The Youngest Visual Art," *Magazine of Art*, 35:7, Nov. 1942, pp. 248-255, ill.
1944 "The Scope of Action Photography," *The Complete Photographer*, National Educational Alliance, New York, 10:4, Mar. 20, 1944, pp. 289-309, ill.
1944 "Growing Americans: Shooting Stills for a Government Short," *U.S. Camera*, VII:1, Feb. 1944, pp. 44-47, 54 ill.
1945 "Modern Dance," *Popular Photography*, 16:6, June 1945, pp. 44-47, 68, ill.
1952 "Is Black & White Better Than Color? No! Says Ivan Dmitri, Yes! Says Barbara Morgan," *Modern Photography*, July 1952, pp. 52-57, 86, ill.
1953 "Kinetic Design In Photography," *Aperture*, No. 4 1953, pp. 18-27, ill.
1955 "The Theme Show: A Contemporary Exhibition Technique," *Aperture*, 3:2, 1955, pp. 24-27.
"The World of Albert Schweitzer," *Publishers' Weekly*, 167:1, Jan. 1, 1955, pp. 68-74, ill.
1956 "Photographer's Ego vs. An Anonymous (?) Medium," *Spectrum Magazine* (Rhode Island School of Design, Providence, R.I.), VI:2, 1956, pp. 12, 21-22.
1963 "Abstraction in Photography," *Encyclopedia of Photography*, Greystone, New York, 1963, Vol. 1, pp. 57-61, ill.
"Advancing Photography as a Fine Art," *Encyclopedia of Photography*, Greystone, New York, 1963, Vol. 1, pp. 77-87, ill.
"Aspects of Photographic Interpretation," *General Semantics Bulletin*, No. 3-31, 1963/64, pp. 44-49 ill.
"Dance Photography," *Encyclopedia of Photography*, Greystone, New York, 1963, Vol. 6, pp. 1013-1024, ill.
"Esthetics of Photography," *Encyclopedia of Photography*, Greystone, New York, 1963, Vol. 7, pp. 1294-1308, ill.
"Juxtapositions in Photography," *Encyclopedia of Photography*, Greystone, New York, 1963, Vol. 10, pp. 1896-1904, ill.
1964 "Barbara Morgan," *Aperture* (monograph), 11:1, 1964, ill.
"Photomontage," *Encyclopedia of Photography*, Greystone, New York, 1964, Vol. 15, pp. 2841-2851, ill.
1965 "Russell Lee, Photographer," in *Russell Lee—Retrospective Exhibition* 1934-64, (catalogue), University Art Museum, University of Texas, Austin, 1965, p. 4
1971 "My Creative Experience with Photomontage," *Image*, 14:5-6, 1971, pp. 18-20, ill.

Selected List of Articles about Barbara Morgan

1938 Kelley, Etna, M., "Barbara Morgan: Painter Turned Photographer," *Photography*, 6:73, Sept.
1941 Isaacs, Edith J. R., "Graham Dance Record," *Theatre Arts Monthly*, Dec.
Lloyd, Margaret, "Portraits of Energy," *Christian Science Monitor*, Nov. 1
"Martha Graham: Sixteen Dances in Photographs by Barbara Morgan," book review), *U.S. Camera*, Dec.
McCausland, Elizabeth, "Dance Photographs by Barbara Morgan," *Springfield Sunday Union and Republican*, Sept. 7.
1944 "A Danca Moderna," *Em Guarda* (Brazil), 4:7.
1945 "Apertura de la Exposicion 'La Danza Moderna Norte-Americana'," *El Mundo* (Havana), Sept. 21.
"A Photographic Exhibition of the Modern American Dance," *Dance Observer*, May.
1947 "Photographic Exhibition of Modern Dance," *The Standard* (Argentina), June 19.
"Photographic Study of the 'Modern Dance'," *Buenos Aires Herald*, June 24.
1949 Newhall, Beaumont, *The History of Photography from 1839 to the Present Day*, Museum of Modern Art, New York.
1951 Abbott, Berenice, "Summer's Children" (book review), *American Photography*, Nov.
Benet, Rosemary, "Summer's Children" (book review), *Book-of-the-Month Club News*, Oct.
Newhall, Nancy, "Journey Into Childhood," *Popular Photography*, Oct.
"Summer's Children by Barbara Morgan" (book review), *Art News*, Sept.
1952 Haskell, Helen, "Summer's Children: Life at Camp," *Living Wilderness*, 17:41, Summer.
Lewis, Harold, "On Illustrating a Book," *Photography*, 7:4, April.
Neugass, Fritz, "Great American Photographers: Barbara Morgan," *Camera*, 31:2, Feb.
Newhall, Beaumont, "Barbara Morgan, Summer's Children" (book review), *Magazine of Art*, Mar.
1954 Hering, Doris, ed., *25 Years of American Dance*, Orthwine, New York.
1964 "Barbara Morgan," *Encyclopedia of Photography*, Greystone, New York, 1964.
1965 Bennett, Edna, "The Boom In Picture Books," *U.S. Camera*, 28:3, Mar.
Neugass, Fritz, "Die vielen Gesichter der Barbara Morgan," *Foto Magazin* (Munich), July.
1969 Deschin, Jacob, "Archival Printing—Push for Permanence," *Popular Photography*, 69:2, Aug.

1971 Deschin, Jacob, "Barbara Morgan: Permanence Through Perseverance," *Photography Annual.*

Hering, Doris, "Barbara Morgan: One of America's Great Photographers Reflects a Decade of Dance 1935-1945," *Dance Magazine*, July.

"Barbara Morgan: Inner Dialogues with the External World" (interview), *Quadrille*, Vol 5, No. 4, Bennington College.

1972 Coppens, Jan, "Barbara Morgan: fotographe tussen twee wereldoorlogen," *Foto* (Amsterdam), 27:7, July.

1973 Lawrence, Clive, "An Explosion of Energy," *Christian Science Monitor*, Jan. 13.

UCLA Daily Bruin, Los Angeles, California (exhibit review), Oct. 18.

Saturday Review World, "Barbara Morgan Monograph" (book review), Nov. 6.

1974 Chapin, Louis, *Christian Science Monitor* (interview), Feb.

Viva, New Mexico (exhibit review), April.

Albuquerque Journal, New Mexico (exhibit review), April 4.

Deshin, Jacob, "Here's How They Get Those Offbeat Effects," *Popular Photography*, Summer.

Deshin, Jacob, *The Photo Reporter*, August.

Women and the Arts: Art in Society, University of Wisconsin, Summer.

Craven, George, *Object and Image*, Prentice-Hall, Winter.

Ovo Photo, Montreal, Quebec, November.

Exposure: Journal of the Society for Photographic Education, Sept.

"The Woman Artist," *Art and Man*, Scholastic for National Gallery of Art, Fall.

Doty, Robert (ed.), *Photography in America*, Random House for The Whitney Museum of American Art, Fall.

1975 *Dictionary of International Biography*, Cambridge, England.

Kisselgoff, Anna, *New York Times*, interview, June 19.

Art: A Woman's Sensibility, Institute of the Arts, Valencia, California.

Spencer, Ruth, *The British Journal of Photography*, article, June 13.

Beaton, Cecil and Buckland, Gail (eds.), *The Magic Image: The Genius of Photography from 1839 to the Present*, Weidenfeld & Nicholson, London.

1976 Panier, Deborah, "All the Atoms are Dancing," *Washington Calendar Magazine*.

1977 Allen, Casy, "Barbara Morgan," *Camera 35*, May.

1978 Loercher, Diane, "The Essence of Dance," *Christian Science Monitor*, Sept. 18.

Salbitani, Alberto A., "Taccuino Americano: Barbara Morgan." *Progresso Fotographico*.

Selected List of Lectures and Seminars by Barbara Morgan

1939 "Dance Photography and Photo-Montage," Brooklyn Museum, Brooklyn, N.Y.

"Photomontage," Photo League, New York, N.Y.

1940 "Contemporary Photography," Brooklyn Community Art Center, New York, N.Y.

"Photography of the Dance," Manhattan Camera Club, New York, N.Y.

1941 Clarence H. White School of Photography, New York, N.Y.

1942 "Photography vs. Painting," WABC Radio (with Reginald Marsh), New York, N.Y.

1943 "Photography and the Modern Dance," Y.M.H.A. Lexington Ave., New York, N.Y.

"Action Photography," Museum of Modern Art, New York, N.Y.

1944 "Imagination In Photography," Museum of Modern Art.

"Photographic Vision" and "Control of Elements and Technique in Photographic Expression," Black Mountain College, Black Mountain, North Carolina.

1945 "Creative Lighting," Museum of Modern Art, New York, N.Y.

1947 "Photography As A Creative Art," ASMP Symposium, New School for Social Research, New York, N.Y.

1956 Village Camera Club, New York, N.Y.

1960 "From Cave Paintings to Contemporary Art," ten lectures, Edgemont Adult School, Scarsdale, New York.

1963 "Aspects of Photographic Interpretation," Conference on General Semantics, Institute of General Semantics, New York University, New York, N.Y.

1964 "The Future of Pictures in the Library," panel discussion, Special Libraries Association, Donnell Library, New York, N.Y.

1965 "Dynamics of Composition," Hudson River Museum, Yonkers, New York.

1968 "Analogue: A Conversation Between Barbara Morgan and Gordon Parks on Their Experiences in Photography," Radio WLIB, New York, N.Y.

1970 Summer Dance Festival, Connecticut College, New London, Connecticut.

Visual Studies Workshop, Rochester, New York.

1971 Ansel Adams Yosemite Workshop, Yosemite, California.

Bennington College, Bennington, Vermont.

"Objective/Subjective Vision," Montclair Art Museum, Montclair, New Jersey.

Oral History Program Interview Sessions, University of California at Los Angeles.

1972 Ansel Adams Yosemite Workshop, Yosemite, California.

Cooper Union Forum, New York, N.Y.

Lectures and Seminars

1973 "Photography of the Dance," Katonah Gallery, New York.

Sarah Lawrence College, Bronxville, New York

UCLA, Los Angeles, California.

Friends of Photography, Carmel, California.

1974 New Orleans Museum of Art, Louisiana.

Institute of New Mexico, Albuquerque, New Mexico.

1975 "Objectivity and Subjectivity: Photography as Art," Marquette University, Milwaukee, Wisconsin.

Hastings Creative Arts Council, Hastings-on-Hudson, New York.

Rhode Island School of Design, Providence, Rhode Island.

1976 UCLA, Los Angeles, California.

Orange Coast Community College, California

American Dance Guild Conference, Boston, Massachusetts

Manhattanville College, Purchase, New York

"Creative Image," workshop, Columbia College, Chicago, Illinois.

University of California Extension Santa Cruz, Mendocino.

1977 "Documenting America in the Thirties: The Photographers of the F.S.A.," symposium, Brooklyn Museum, New York.

SUNY, Purchase, New York.

Marquette University, Milwaukee, Wisconsin.

Sheldon Art Gallery, U. of Nebraska, Lincoln, Nebraska.

New England School of Photography, Boston, Massachusetts.

1978 Montclair State College, New Jersey.

Sarah Lawrence College, Bronxville, New York.

Manhattanville College, Purchase, New York.

Catskill Center for Photography, Woodstock, New York.

1979 Ohio University College of Fine Arts, Athens, Ohio.

Rochester Institute of Technology, Rochester, New York.

Duke University, Durham, North Carolina.

Purdue University, Lafayette, Indiana.

1980 "Ten Women of Photography," Mills College, Oakland, California.

Grand Rapids Art Museum, Michigan.

1981 "The Early Years: American Modern Dance," symposium, SUNY, Purchase, New York.

"Thoughts of Photography," Amon Carter Museum, Fort Worth, Texas.

1982 Northwestern University, Evanston, Illinois.

1983 International Center of Photography, New York, N.Y.

1984 Hudson River Museum, Yonkers, New York.

"Creativity in the 80's," panel, Queensborough Community College, New York.

Columbia University, New York, N.Y.

1985 Hampshire College, Amherst, Massachusetts.

Selected List of Group Exhibitions

1937 "First Annual Membership Exhibition," American Artist' Congress, New York, N.Y.
1938 "International Photographic Exposition," Grand Central Palace, New York, N.Y.
"Outstanding Women Photographers of America," Carl Zeiss, Inc. New York, N.Y., circulated nationally by Junior League.
1939 "Art in a Skyscraper," American Artists' Congress, New York, N.Y.
"Dance Exhibition," Los Angeles Museum of History, Science and Art, Los Angeles, California.
1940 "American Dancing," Museum of Modern Art, New York, N.Y.
"Invitational Salon," Photographic Society of America, Worlds Fair, New York, N.Y.
1941 Philadelphia Art Alliance, Philadelphia, Pennsylvania.
Photographic exhibition, British War Relief Society and Manhattan Camera Club, New York, N.Y.
1942 Photographic exhibition, Photograph Exhibit Committee of the Citizens Committee for the Army and Navy and Museum of Modern Art, New York, N.Y, traveling exhibition.
1943 "Action Photography," Museum of Modern Art, New York, N.Y.
School of Fine Arts, Yale University, New Haven, Connecticut.
1944 "A Century of Photography," Museum of Modern Art, New York, N.Y., traveling exhibition.
1945 "Creative Photography," Museum of Modern Art, New York, N.Y., traveling exhibition.
"Modern Dance—1945," New York Public Library, New York, N.Y.
1946 Society of the Friends of Art, Cairo, Egypt (circulated by Interim International Information Service, Office of War Information, New York, N.Y.).
1948 "In and Out of Focus," Museum of Modern Art, New York, N.Y., traveling exhibition.
"This Is the Photo League," Photo League, New York, N.Y.
1952 "World Exhibition of Photography," Lucerne, Switzerland.
1954 "This Is the American Earth," California Academy of Science and Sierra Club, San Francisco, California, traveling exhibiton.
1955 "C.S. Association Traveling Exhibition of International Photography, 1955-57," London, England, traveling exhibition.
"The Family of Man," Museum of Modern Art, New York, N.Y., traveling exhibition.

1957 "I Am Involved In Mankind," National Conference of Christians and Jews, New York, N.Y.
"I Hear America Singing," United States Information Agency, Washington, D.C., traveling exhibition.
"Volk Aus Vielen Volkern" ("A Nation of Nations"), U.S.
Information Agency, Berlin, Germany, traveling exhibition.
1959 "Photographs from the Museum Collection," Museum of Modern Art, New York, N.Y.
1960 "The Invisible World Revealed," George Eastman House, Rochester, New York.
"Photography In the Fine Arts II," Metropolitan Museum of Art, New York, N.Y., traveling exhibition.
1965 Kodak Pavilion, World's Fair New York, N.Y.
The White House Festival of the Arts, Washington, D.C.
1967 "Photography in the Fine Arts V," Metropolitan Museum of Art, New York, N.Y., traveling exhibition.
1968 Chicago Exchange National Bank, Chicago, Illinois.
"Light 7," Massachusetts Institute of Technology, Cambridge, Massachusetts, traveling exhibition.
1969 "The Art of Photography," National Arts Club, New York, N.Y.
"Spectrum 2: Barbara Morgan, Naomi Savage, Nancy Sirkis," Witkin Gallery, New York, N.Y.
1970 "Be-ing Unclothed," Massachusetts Institute of Technology, Cambridge, Massachusetts.
1971 "Portraits of the American Stage 1771-1971," National Portraits Gallery, Washington, D.C.
1972 "Multiples and Graphics," Katonah Gallery, Katonah, New York.
"Octave of Prayer," Massachusetts Institute of Technology, Cambridge, Massachusetts.
"Ten New England Women Photographers," Wellesley College Museum, Wellesley, Massachusetts.
1973 Society for Photographic Education, Public Theatre, New York, N.Y.
"Super-Cream," Muckenthaler Cultural Center, Fullerton, California.
"Light and Lens," Hudson River Museum, Yonkers, New York.
Archetype Gallery, New Haven, Connecticut.
1974 Louis Horst Exhibition, Lincoln Center, New York, N.Y.
The Currrier Gallery of Art, New Hampshire.
Robert Schoelkopf Gallery, New York, N.Y.
"Photography in America," Whitney Museum of American Art, New York, N.Y.
La Bibliothèque Nationale, Montreal.

1975 Neikrug Gallery, New York, N.Y.
"Women of Photography," San Francisco Museum of Art, travelling exhibition.
"International Women's Art Festival," FIT, New York, N.Y.
The Hudson River Museum, Yonkers, N.Y.
1976 "200 Years-America on Stage," JFK Center for the Performing Arts, Washington, D.C.
"The Photographer and the Artist," Sidney Janis Gallery, New York, N.Y.
United States Information Agency, worldwide travelling exhibits 1975-77.
UCLA, Los Angeles, California.
Witkin Gallery, New York, N.Y.
"Women See Women," The First Women's Bank, New York, N.Y.
"Women Photograph Men," International Women's Arts Festival, New York, N.Y.
LIFE's "Remarkable American Women," International Center of Photography, New York, N.Y.
1977 "The Women's Art Symposium," Indiana State University, Terre Haute, Indiana.
"The Woman's Eye," Charlottenburg Castle, West Berlin.
"Women See Men," M.I.T., Cambridge, Massachusetts.
1978 "Photography-A Celebration," Katonah Gallery, New York.
"Photo-Flow IV," Catskill Center for Photography, Woodstock, New York.
"Fleeting Gestures," International Center of Photography, New York, travelling exhibit.
1979 "America between the World Wars," Kunsthaus, Zurich
1980 "Working Women-1840-1945," Whitney Museum of American Art, Downtown Branch, New York, N.Y.
"Women/Images/Nature," Tyler School of Art, Temple University, Philadelphia, Pennsylvania.
1981 Bruce Museum, Greenwich, Connecticut.
1982 Floating Foundation of Photography, New York, N.Y.
1983 "Arboratum," University of Colorado, Denver, Colorado.
1984 *"American Dance Festival," Duke Art Museum, Durham, North Carolina.*
1985 Aldrich Museum of Contemporary Art, Ridgefield, Connecticut.
1986 University of Oregon Museum of Art, Eugene, Oregon.
Port of History Museum, Philadelphia, Pennsylvania.
1987 "La Danza Moderna Di Martha Graham," Teatro Municipale, Valli Di Reggio, Emilia, Italy.

Selected List of Institutions with Barbara Morgan Prints in Permanent Collection

Addison Gallery of American Art, Andover, Massachusetts.
Amon Carter Museum, Fort Worth, Texas.
Bennington College Library, Bennington, Vermont.
Detroit Public Library, Detroit, Michigan.
Hudson River Museum, Yonkers, New York
International Museum of Photography, Rochester, New York.
Library of Congress, Prints and Photographic Division, Washington, D.C.
Lincoln Center Library and Museum of Performing Arts, New York, N.Y.
Marquette University, Haggerty Museum of Art, Milwaukee, Wisconsin.
Massachusetts Institute of Technology, Photography Collection, Cambridge, Massachusetts.
Metropolitan Museum of Art, New York, N.Y.
Museum of Fine Arts, St. Petersburg, Florida.
Museum of Modern Art, New York, N.Y
National Gallery of Canada, Ottawa.
National Portrait Gallery, Washington, D.C.
New Orleans Museum, New Orleans, Louisiana.
Philadelphia Museum of Art, Philadelphia, Pennsylvania.
Phoenix College, Phoenix, Arizona.
Princeton University Library, Princeton, New Jersey.
Rochester Institute of Technology, Rochester, N.Y.
Santa Barbara Museum of Art, Santa Barbara, California
Smithsonian Institution, History of Photography Collection, Washington, D.C.
State University of N.Y., College at Purchase, Neuberger Museum, New York.
University of California at Los Angeles, Frederick S. Wright Gallery, Los Angeles, California.
University of California at Los Angeles Library, Los Angeles, California.
University of Colorado, Denver, Colorado.
Utah State University Galleries, Logan, Utah.
Wesleyan University, Davison Art Center, Middletown, Connecticut.

Radio, Television, Video

1973 Radio (Station WNYC-AM): "The Changing World of Women," interview by Phyllis Sanders.
1974 Radio (Staton KVSF): "Impact News," interview by Bob Barth, Sante Fe, New Mexico.
Television (UHF Channels 31): interview by Casey Allen.
Film: "Vision USA: Barbara Morgan—Photographer," for U.S. Information Agency (Craven Films, New York).
Video: New Orleans Museum of Art, Chaster Kasnowski.
1975 Video: "Barbara Morgan" by Rikki Ripp.
1976 Radio (Station WFAS): "Faces at Bloomingdales," interview by Ms. DelBello.
1980 Video: Interview by Barbaralee Diamondstein at Parsons School of Design, New York, N.Y.
1983 Video: "Barbara Morgan—Everything is Dancing" by Checkerboard Foundation, New York, N.Y.
Video by Images Production, Cincinnati, Ohio.

Books by Barbara Morgan

Martha Graham: Sixteen Dances in Photographs, Duel, Sloan and Pearce, New York, 1941.
Prestini's Art in Wood (text by Edgar Kaufmann, Jr.), Pocahontas Press, Lake Forest, Illinois, 1950.
Summer's Children, Morgan & Morgan, Scarsdale, N.Y., 1951.
Barbara Morgan, A Morgan & Morgan Monograph, Hastings-on-Hudson, New York, 1972.
Barbara Morgan Photomontage, Morgan & Morgan, Dobbs Ferry, New York, 1980.